IMAGES
of America

RUTHERFORD

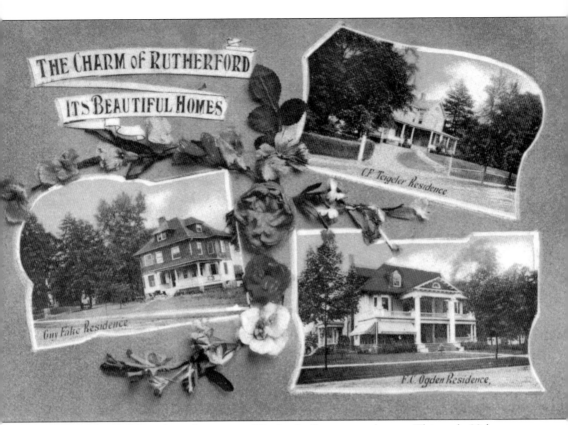

THE CHARM OF RUTHERFORD

ITS BEAUTIFUL HOMES

C.F. Teigeler Residence

Guy Fake Residence

F.C. Ogden Residence,

Beautiful homes have always been one of Rutherford's greatest charms. This early 20th century postcard boldly presents three outstanding examples of vernacular architecture with the homes of Judge Guy Fake, Charles F. Teigeler, and Rutherford homebuilder Fredrick C. Ogden. (Courtesy Kathy Howard.)

ON THE COVER: Cruising up and down Park Avenue is a fundamental joy in Rutherford. From the 1940s up to the present, drivers have always found reasons to take the car out for a spin with friends. (Courtesy Anne Rogers Jurkowski.)

IMAGES
of America

RUTHERFORD

William Neumann

ARCADIA
PUBLISHING

Published by Arcadia Publishing
Charleston, South Carolina

Printed in the United States of America

Library of Congress Control Number: 2012940479

For all general information, please contact Arcadia Publishing:
Telephone 843-853-2070
Fax 843-853-0044
E-mail sales@arcadiapublishing.com
For customer service and orders:
Toll-Free 1-888-313-2665

Visit us on the Internet at www.arcadiapublishing.com

*This book is dedicated to the men and women who have shared
their lives with our town by settling, strengthening, planning,
and protecting the people and places throughout the Borough
of Rutherford. Where would we be without your history?*

CONTENTS

Acknowledgments 6

Introduction 7

1. Early Rutherford History 101 11

2. Cornerstones 21

3. Enlightenment and Entertainment 39

4. Education and Worship 59

5. Rutherfordians and Their Homes 91

6. Public Service and Just Business 107

Bibliography 127

ACKNOWLEDGMENTS

It would seem like a simple task to assemble words and images into a devotional for a place you love. Not so, since Rutherford stories are endlessly rich, and choosing which ones to relate and which images to illustrate them was a daunting task. One book could never completely contain the entirety of Rutherford's enduring history, and this one will not attempt to.

Every history book is a derivative work that depends on previous research as well as resources discovered today. I was fortunate to have the help and the resources of the Rutherford Public Library and their dedicated staff, the librarians of the Bergen County Historical Society, the family archives of the Van Winkle and Williams families, and Fairleigh Dickinson University. I was blessed to have historian and genealogist Nancy Terhune sign on for another editing voyage as she steered me away from the literary rocks of incoherence. Will this be the first history book to acknowledge a Facebook community of Rutherfordians? Yes, and thank you all!

My grateful appreciation for all the following vast sources of images and inspiration: the private collections of Mary Melfa and Virginia Marass, Gene Hilt, Rutherford historian James Hands, City of Passaic historian Mark Auerbach, Anne Rogers Jurkowski, Edward and George Lisy, Carl and Renee Schlessinger, Marie Barthlome, Anne McCormack, the Rutherford faith community, the institutions of the Rutherford Public Library, the Borough of Rutherford, New York Public Library, *Rutherford Republican* and *American* newspapers, *South Bergen News*, and *South Bergenite* and *News Leader* newspapers.

Unless otherwise noted, all images are from the author's collection of original and derivative images of the history of the Borough of Rutherford. Please visit www.RutherfordHistory.com for more information.

INTRODUCTION

Outsiders may wonder about this little state's great abundance of Native American names, but New Jerseyians who cherish their early history know the real story. Before any Europeans inhabited the Rutherford area, the Lenni Lenape, or Lenapehoking people, traveled along a tramped-down pathway, possibly just the width of three abreast, that ran between the Piasiak (Passaic) and the Ackensack (Hackensack) Rivers. As the Dutch and the British attempted settlements, this trail became the only east-west marker that could delineate this area's first two royal land patents. The 1669 Nathaniel Kingsland land patent began near the 1666 Puritan settlement of New-Ark and stretched north, ending at this "Old Indian Trail." The trail would serve as a common divider between the northern terminus of the Kingsland patent and the southern boundary of the 1669 John Berry patent, which ran six miles north from the trail to Hackensack. Waling Jacobs (eventually the family was renamed to the familiar Van Winkle) was the first settler in the Rutherford area. He established his 1690 homestead close to the banks of the Passaic River near present-day Hastings and Darwin Avenues. Waling wisely chose to live close to the Old Indian Trail in order to use its transit between the two rivers as well as for its proximity to the Acquackanonk (now Passaic) settlement and church just on the opposite side of the Passaic River. This Old Indian Trail would later roughly describe the east-west route of Boiling Spring Lane, known today as Union Avenue.

Beginning in the late 17th century, present-day Rutherford was contained within the area known as New Barbadoes Neck. It was an isolated area, effectively a peninsula surrounded by water and wetlands. It was a strictly rural farmland with no established village or churches. The Jurianse (Yereance), Kips, and Van Winkle families maintained the scattered farms and settlements in the area. Most travel was accomplished on the surrounding rivers or on foot. Besides the Native American trails, the first road established was the appropriately named Riverside (Avenue) in 1716. This rough road ran north and south and connected the Jurianse farm, the Van Norstrand farm, and the Van Winkle farm as neighboring settlements along the Passaic River. It would take a good part of the 18th century, but farms slowly evolved along the next important Rutherford area road. Neck Road (1794) skirted the area's eastern marshlands and started in the north near the Hackensack area and then south (via Polifly Road) to Newark. Appropriately, Neck Road would be named Newark Road, which is known today as Meadow Road. It was along this important north-south connector that Rutherford area settlements actually began to take hold and thrive. These Neck Road residents, including the Yereance, Ackerman, Kips, and Outwater families, established the first core settlement in the Rutherford area.

The borough's namesake, John Rutherfurd, moved his family to the New Barbadoes Neck area in 1808. After serving as the second elected US senator from New Jersey (1791–1798), he established his new estate, Edgerston, on the east bank of the Passaic River in today's Lyndhurst area. He remained active in politics, helping to design the street grid plan for New York City and strongly advocating for a statewide canal system of transportation. The Rutherfurd family grew

to become some of the largest landowners in New Jersey while they speculated in local property development. Senator Rutherfurd lived the rest of his life on his Passaic River estate and died there on February 23, 1840.

Just as John Rutherfurd was advancing canals as the best means for future transportation, a revolutionary idea was developing in the industrial city of Paterson, New Jersey. The railroad industry had much of its start through the pioneering efforts of the John Stevens family in Hoboken. Paterson businesspeople began to envision a link from their mills to the markets of New York City. Early railroad development, however, was in direct competition with established canal investments in New Jersey. As the conflict peaked, the New Jersey state legislature decided to affirm both ideas, endorsing charters for rails and canals in one bill. The Paterson & Hudson River Rail Road Company (PHRR) wasted no time and incorporated on January 21, 1831, commencing operation in June 1832. It first established a train line from downtown Paterson south to the important river port of Acquackanonk Landing (City of Passaic). Constructing what many people believe was the first movable railroad bridge over a river, it finally crossed the Passaic and into the sleepy rural area known as Boiling Spring.

For all living things, water features were always important destinations. When the engineers and surveyors were planning the PHRR route toward New York City, the descriptive Boiling Spring became a logical place through which to pass a railroad. These springs were an ever bubbling (though not hot) concentration of ready aquifers located at the end of Boiling Spring Lane and close to Neck Road in what today is termed the Station Square area of Rutherford. It was a fine place to stop to water animals and locomotives before crossing the inhospitable meadows towards New York City.

The first trains did not roar through the Rutherford area until 1835. In fact, the first trains did not make much noise at all, as "swift and gentle horses" originally pulled them. But for Boiling Spring, the change was as startling as thunder. When the locomotive approached a water stop, its bell rang, and farmers knew it was time to send their excess produce to market and eventually find markets to sell their excess farmlands. As rail passengers made their way to businesses and investments in Paterson mills, New Yorkers looked out their train windows and realized how close the quaint country village of Boiling Spring was to their overcrowded city life.

Beginning at the outbreak of and continuing during the Civil War, the railroad funneled a steadier stream of population and land investments into Boiling Spring. The small Van Winkle Mill in Union Township, established around 1820, grew to be known as the Boiling Spring Bleachery. It was located beside a natural, spring-fed lake, Swanwhite Park, or "Lake in the Woods," in the western part of the area near the Passaic River and very close to the railroad. The village of Boiling Spring was now part of the larger entity called Union Township and also a part of Bergen County. As the population expanded and diversified, social services grew. At the conclusion of the Civil War, the village of Boiling Spring contained a few fledgling churches, some enterprising retailers, a school, and the start of a simple postal system. These important social centers helped turn an isolated rural farmland and summer retreat area into a growing, prosperous township.

Important civic leaders arose to guide village development. Floyd W. Tomkins was an early and energetic booster who came from New York and realized the extraordinary quality of life afforded by the village of Boiling Spring. In 1858, he obtained a little stone cottage on Boiling Spring Lane (still extant at 245 Union Avenue) and was a cofounder of the area's first land association, known as the Villa Sites at Boiling Spring. His partner Daniel Van Winkle was a fifth-generation descendant of Rutherford's original settler Waling Jacobs (Van Winkle). Daniel and his family operated a general store right across from the main stop on the railroad. The Van Winkle family had prospered by providing real estate and property services to the growing influx of interested New Yorkers. Daniel Van Winkle donated land for a proper railroad station and the service areas it required. Throughout the following quarter of a century, 10 additional land associations were born. Farmland was regularly sold for residential use through property partnerships, such as the Mount Rutherford Company, Rutherford Heights Association, and the Rutherfurd Park Association. It

would seem that heavy industry never had a chance to establish a chilling presence in the march from farms toward residential settlement.

After the Civil War, much of Rutherford's present streets and avenues had been set out or were being planned. Boiling Spring Lane, once the Old Indian Trail, was now a busy thruway renamed Union Avenue. Prosperity brought increased need for home construction. Many of Rutherford's Second Empire Victorian-style homes were first illustrated in the pages of popular pattern books authored by two Rutherford neighbors, E.C. Hussey and George Woodward. These books—along with others—were used to demonstrate to builders and their clients how to construct a modern home and what it should look like when finished. Throughout the 1870s and into the first part of the 20th century, a great variety of interesting houses and civic structures were built. These included the whimsical Iviswold, a high-style, chateauesque castle built for David Brinkerhoff Ivison by the architect William H. Miller, and a new and expansive 1898 Rutherford train station designed and constructed by Erie railroad's chief engineer Charles W. Buchholz.

Change was in the air as the old Boiling Spring village name gave way to Rutherfurd, Rutherfurd Park, and then Rutherford Park. These variants of the name were used interchangeably and were intended to honor the long-departed US senator John Rutherfurd and his family's stature in promoting local development. In the early 1880s, a perception that tax monies were slipping away to distant corners of Union Township angered these affluent villagers. Through the guidance of Union Township attorney Luther Shafer, many of the residents believed they could simply secede from the larger township by popular referendum. Shafer encouraged his Rutherford neighbors to form a new governmental division called a "borough." New borders somewhat reflective of those found today were drawn, and an election was held. On September 21, 1881, after the vote was validated, the "Mayor and Council, Borough of Rutherford" (actual name) was recognized. Still, it would be almost 10 years until today's borders were finally codified, local control could be fully implemented, and the name thankfully shortened to the Borough of Rutherford.

As the 20th century began, Rutherford aggressively protected and exploited the best qualities of its residential nature. Shunning encroaching smokestacks, it instead built and then rebuilt schools, churches, social centers, parks, and a library. An initial construction spurt in the 1890s was followed by another around World War I. By 1901, the town had an established and central post office, an armory, and a real borough hall within the 82–92 Park Avenue building complex. The march of technology through gas, electric, water, sewage, and telephone utilities eased life while quality police and fire departments protected it. Local employment could be found in the emerging Becton Dickinson factory, Standard Bleachery (once the Boiling Spring Bleachery), Julius Roehrs, or the Bobbink and Atkins greenhouses, or even the Rutherford Rubber Company or Rutherford Machinery; but all were located in East Rutherford, as industry always remained just a bit beyond the borders of Rutherford proper.

In spite of always being a dry town with no public bar service permitted, Rutherford's expansive downtown became the center of commerce to a surrounding population of nearly 50,000. More amenities followed, including social and athletic organizations like the Union Club, Elks, Odd Fellows, Royal Arcanum, Masons, Rutherford Wheelmen, Women's Reading Club, Boat Club, and the influential Rutherford Improvement Association. Legitimate theaters soon included the 1912 Criterion on Ames Avenue and the 1922 Rivoli on Sylvan Avenue.

The "War to End All Wars" took 19 Rutherford lives and changed the town. Afterward, residential and civic architecture vastly improved. New homeowners found themselves within an emerging New York City suburb with some affluence but less and less land to build on. Now driven by practicality, many homes assumed a more beefy, American Foursquare footprint within this diminishing landscape. These were mixed in with smaller Craftsman bungalows and Colonial Revival center halls that fit nicely on a compact 75-foot-by-100-foot building lot. Improvements to the borough's quality education coincided with a new Rutherford High School, opened in 1922, and the establishment of St. Mary's parochial school system in 1932. Rutherford's civic center began to be established at the top of Park Avenue just across from tranquil Lincoln Park. Edgar I. Williams designed a fine, new US post office in 1935. The abandoned Park School was

transformed by local architects Huesmann and Osborne into a handsome borough hall and opened in 1939.

Returning World War II veterans eventually found affordable housing in both quality and quantity within the developing Memorial Field and Sandys area in the borough's West End. The Borough of Rutherford continued to increase its social cachet through additional churches, clubs, civic organizations, parks, and recreation. By mid-century, Rutherfordians started to realize that old Doc Williams was actually a pretty important poet. It seemed that since 1909, he had been composing poetry and prose at an astonishing rate. Authors and scholars sought his advice at his home and medical office at 9 Ridge Road. Many termed his poetry revolutionary and eventually lauded him as the greatest poet of the last century.

With the emergence of Fairleigh Dickinson Junior College, veterans also found an intriguing development right in the center of their hometown. The college was conceived in the 1930s by Rutherford couple Peter Sammartino and his wife, Sylvia "Sally" Scaramelli. It was nurtured to life by the Maxwell Becton and Fairleigh S. Dickinson families and the Rutherford National Bank just days before World War II began. The school was initially located in the vacant Iviswold "Castle" property and had as its first class 59 women and one lucky man. When the war ended and the GI Bill was fully in force, Fairleigh Dickinson started its meteoric rise to become the largest private university in New Jersey. Soon it would add two other even larger New Jersey campuses and three international sites and would become Rutherford's largest employer. Because of its residential nature, Rutherford was forced to limit the growth of the original campus complex. During its existence within the borough, the university provided not just jobs and revenue but also intellectual enlightenment and international diversity throughout the entire Rutherford population. Many students and staff took up residence in Rutherford homes and then stayed well past their educational terms. It was therefore a shock with the news of the March 1992 deaths of founders Peter and Sally Sammartino and an even greater one in 1994 when the university administration decided to close the Rutherford campus. Shuttered and dark, the campus seemed doomed as rumors of redevelopment schemes circulated. Then, in 1997, Lodi-based Felician College stepped forward to buy the campus and resurrect its future with a new beginning.

Once again, a new neighbor would start their pursuit of a dream within the Borough of Rutherford.

One

EARLY RUTHERFORD HISTORY 101

In 1630, the Dutch settlement of New Amsterdam expanded off islands within the North River (Hudson River) and onto the mainland of North America. The inland waterways became super highways for exploration by ships, and additional Dutch settlements flowered along the Passaic and Hackensack Rivers. Just as the Dutch put down roots, they were overcome by the arrival of the imperial power of the English. The old Dutch settlements of Acquackanonk (Passaic and Clifton) and Hackensack adapted, prospered, and even empowered their original settlers to acquire new lands from the British. Farms, churches, and governments were crudely connected by rough trails and river travel. During the 18th century, these land connectors evolved into true roads. In the Boiling Spring area (principally Rutherford), the main north-south roads were Neck or Newark Road (now Meadow Road) and Riverside running along the Passaic River. East and west transits were Boiling Spring Lane (once known as the Old Indian Trail, now today's Union Avenue), the Paterson Plank Road, and the Belleville Turnpike.

In 1835, progress shot forward as the Paterson Hudson River Railroad arrived in the village of Boiling Spring. The money of New York City was now connected to the manufacturing of Paterson, and that connection stopped for water at Boiling Spring. After the Civil War, New Yorkers stimulated land speculation as pioneers in retail, churches, schools, construction, banking, mail, and local governance produced successful leaders with visions for the future. By 1881, Rutherford was ready to change and assume its own local control. On September 21, it separated itself from the larger Union Township and incorporated to form the "Mayor and Council, Borough of Rutherford," forever known as "the First Borough of Bergen County."

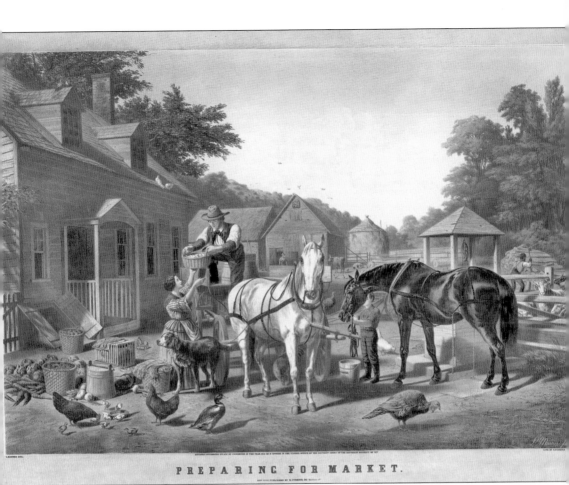

PREPARING FOR MARKET.

A famous 1856 Currier and Ives scene, inspired locally, represented life on the Passaic River in the rural Rutherford area. A somewhat typical Dutch farmer loads his produce for sale at a market. Rutherford historian Jim Hands is familiar with this work and says that *Preparing for Market* is a "Photo-reproduction of a lithograph by Louis Maurer. The scene is of a Holland-Dutch Farm at Passaic, New Jersey, painted by the artist from life. Louis Mayer considered this his best work . . . from his painting done while on summer vacation at Passaic." (Courtesy Jim Hands.)

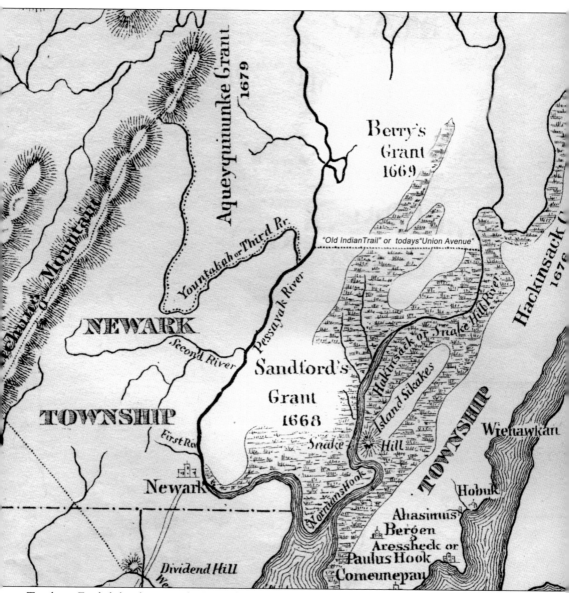

Two large English land grants, the Berry (1669) and Sandford (1668) patents, are described on this map. Together, these grants stretched from Newark to Hackensack and were one of the earliest denoted in New Jersey. Their border was the only known man-made path, referred to as the Old Indian Trail, and was sited approximately where Union Avenue in Rutherford is today.

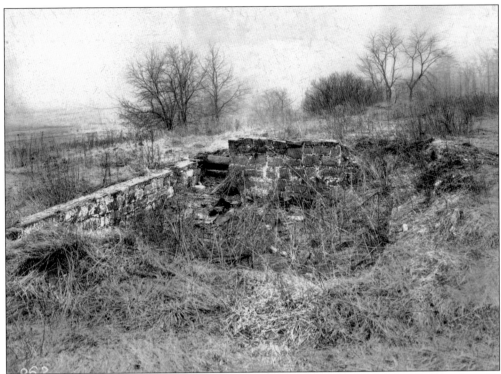

The remains of an early 1700s foundation and a wall belonging to Rutherford's original settler Waling Jacobs were still extant well into the 20th century. According to Theodore Van Winkle, a 10th-generation descendant, Waling's homestead was located on the northwest corner of present-day Hastings and Darwin Avenues. (Courtesy Bergen County Historical Society.)

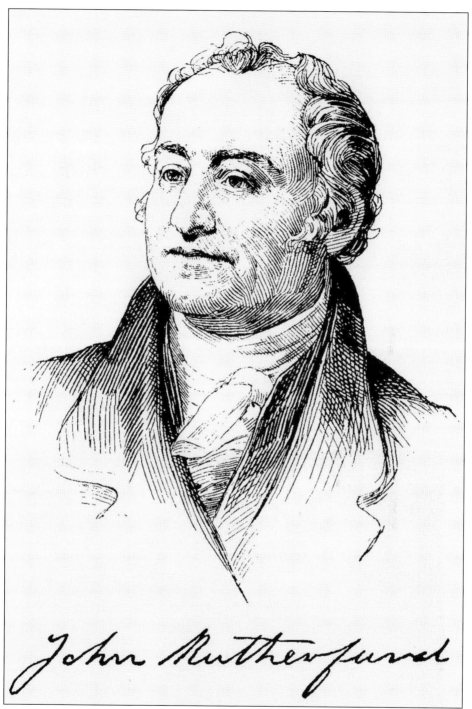

John Rutherfurd was born in New York City in 1760. He was elected as the second US senator from New Jersey and served from 1791 until 1798. In 1804, he moved his family from New York City to a large estate on the Passaic River near today's Bergen County Park in Lyndhurst. After his death in 1840, his family remained very active in local politics and land development. (Courtesy US Senate official biographic illustration.)

PATERSON AND HUDSON RIVER
RAIL ROAD.

THIS Road is now open for the transportation of Passengers from the Depot at Paterson, to the village of Aquackanonk, and the Cars of the Company will start from these places, every day, until further notice, at the following times, viz:

ON WEEK DAYS.

FROM PATERSON.	FROM AQUACKANONK.
At half past 7 o'clk, A. M.	At 8 o'clk, A. M.
" 10 o'clk, do	" half past 10 o'clk, do.
" half past 11 o'clk, do.	" half past 12 o'clk, P. M.
" 2 o'clk, P. M.	" 3 o'clk, do.
" 4 o'clk, do.	" 5 o'clk, do.
" half past 4 o'clk, do.	" half past 6 o'clk, do.

ON SUNDAYS.

At 6 o'clk, A. M.	At 7 o'clck, A. M.
" half past 7 do. do.	" half past 8 do. do.
" 9 do. do.	" half past 9 do. do.
" half past 12 do. P. M.	" half past 1 do. P. M.
" 5 do. do.	" 6 do. do.
" half past 6 do do.	" half past 7 do do.

FARE, 25 *Cents.*—Children under 12 years of age, half price.

E. B. D. OGDEN, *Secretary.*
Paterson, *June 12th* 1832. 29–tf

Everything changed when the Paterson Hudson River Railroad arrived in the village of Boiling Spring in 1835. This very early railroad connected the industrial town of Paterson to the Hudson River and the ferries of New York City. This 1832 poster lists fares and departures and illustrates the horse-pulled train that was originally used. Many believe that the first movable railroad bridge over a river in the United States was built to allow trains to cross from Acquackanonk (Passaic City) into Boiling Spring (Rutherford). (Courtesy Bergen County Historical Society.)

A RAIL ROAD

In Practical Operation within 15 miles of the City of New-York.

THE Paterson and Hudson River Rail Road is formed from the Town of Paterson to the village of Aquackanonk, a distance of four and three-quarter miles, and is now in actual and successful operation between those places.

The Company have placed upon the Road three splendid and commodious Cars, each of which will accommodate at least *thirty* Passengers, and have supplied themselves with fleet and gentle horses, and careful **drivers**.

With a view to suit the convenience of those persons who may wish to avail themselves of this rapid and delightful mode of travelling, the following hours have been fixed for leaving those places.

PATERSON AT	AQUACKANONK AT
Half past 7 o'clock, A.M.	8 o'clock, A.M.
10 o'clock, A.M.	Half past 10 o'clock, A.M.
12 o'clock, M.	¼ before 1 o'clock, P.M.
3 o'clock, P.M.	Half past 3 o'clock, P.M.
4 o'clock, P.M.	5 o'clock, P.M.
Half past 4 o'clock, P.M.	Half past 6 o'clock, P.M.

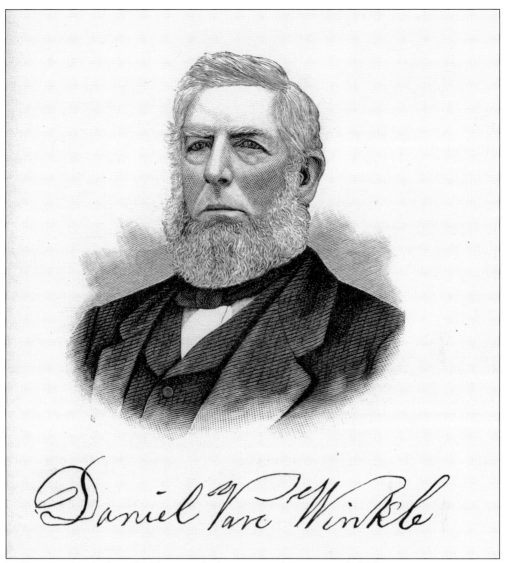

Today's Rutherford might have easily been named "Van Winkelville" or taken the name "Wallingford." From the original settler, Waling Jacob (Van Winkle), to today's descendants, the Van Winkle genealogy spans 12 generations in the Rutherford area. It was Daniel Van Winkle's 19th century civic leadership that began the transformation of the rural area by donating land around Station Square and enticing New Yorkers to invest in residential land in the village of Boiling Spring. (Courtesy Bergen County Historical Society.)

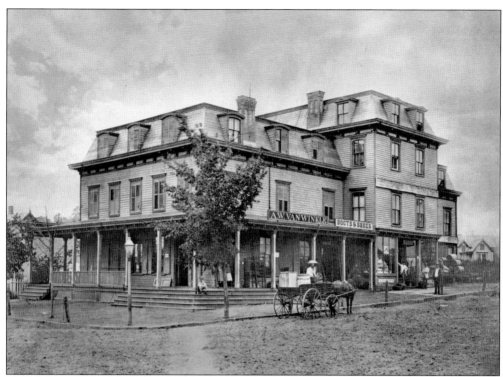

Although very much changed from the 1880 photograph above, the Van Winkle General Store is the site of today's A.W. Van Winkle Real Estate office and is the oldest realty business in the United States. Arthur Ward (A.W.) Van Winkle, the son of Daniel Van Winkle, established an early presence across from the railroad station. From the 1876 Walker Atlas illustration below, it is clear that as trains pulled into town, it was impossible to miss this imposing building on Station Square. (Courtesy A.W. Van Winkle Real Estate.)

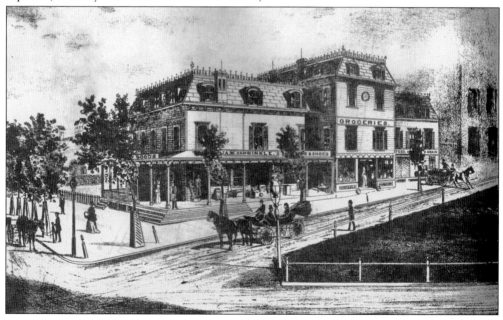

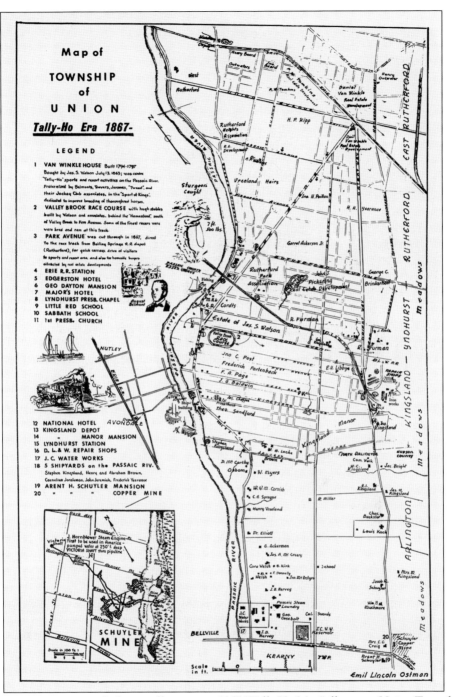

The rare, interesting, and whimsically accurate 1867 "Tally Ho Map" illustrates Union Township's general boundaries, important retailers, hotels, water features, major roads, and points of interest. It is a "landowners map," as it roughly locates historic structures and names their owners. Its coverage stretches from the southern part of the township to the Rutherfurd Estate, Edgerston, and nearby Valley Brook Race Course all the way to the Rutherford (Erie) Railroad Station in the village of Boiling Spring.

19

Luther Shafer, known as "the father of the borough form of government," was a Rutherford-area attorney who represented Union Township. He understood the dissatisfaction of his neighbors regarding taxes and revenue spent away from its source. In 1881, he rallied the people of Rutherford to attempt to secede from Union Township by referendum. On September 21, 1881, the Mayor and Council, Borough of Rutherford was formed. (Courtesy Bergen County Historical Society.)

Two

CORNERSTONES

Many prominent buildings are erected around cornerstones. Making a mark in stone to herald the genesis of a building allows a viewer to consider his or her place in human history and then the structure's specific relevance to one's life. In the life of a town, entire buildings, objects, and places can function as community cornerstones. Throughout the history of Rutherford, many cornerstones have been created so that even today their function, setting, and beauty give pause and reflection. Many of these signify amazing beginnings and, sometimes, sudden ends. Most were carefully planned to enhance the lives of a population as a whole. Some were created for individual desires and needs. A few were simply markers of milestones in a town's dynamic development. Continued preservation of these cherished cornerstones illuminates the history of a town and its achievements.

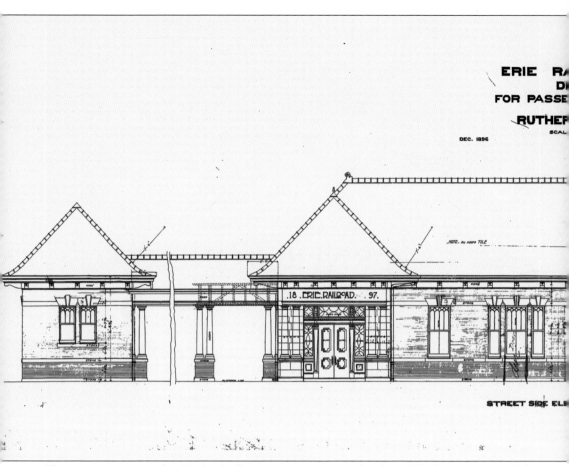

.18 . ERIE. RAILROAD. . 97.

NOTE. ALL ROOFS TILE

STREET SIDE ELE~

There is no question that Rutherford's unique train station has been "the" cornerstone of the borough for over 110 years. From these original plans, it is obvious that the Erie Railroad's chief engineer, Charles W. Bucholz, designed the present station in 1896. The need for a station to afford both comfort and quick conveyance is expressed by the horizontal rhythm of enclosed passenger structures and open porticos for baggage and freight handling. The station's exterior fabric includes smooth, red brick in a common bond with red-tinted mortar that is trimmed with

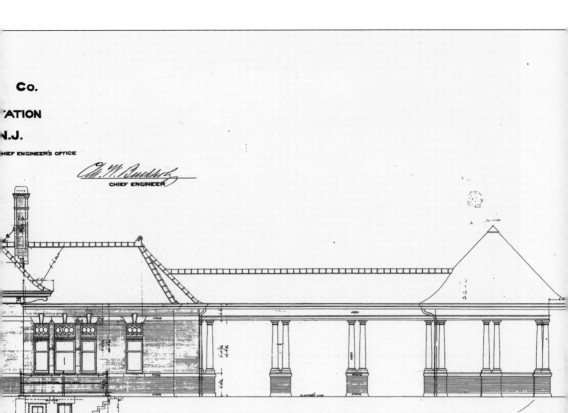

tooled limestone sting courses and keystones. The asymmetrical roofline has seven hipped and gabled sections covered in green tile and is supported by paired colonnades surrounding the open porticos. The most easterly feature is a circular belvedere, or gazebo, which looks out upon the Hackensack meadows. In total, the station area was enlarged to 374 feet when construction was completed in 1898. (Courtesy New Jersey Transit.)

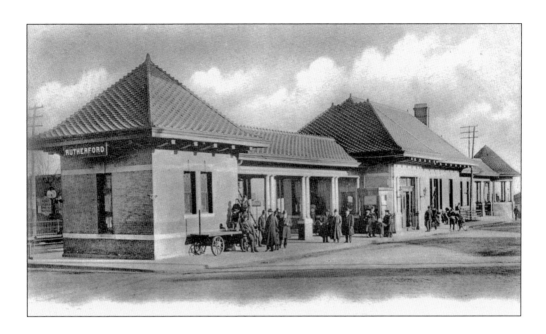

The 1907 image above shows the squared off express/freight office at the western end of the Rutherford Train Station. This section was steps away from Station Square and Lempert's store, which housed one of the first telephones in town. Freight and baggage was handled here. Passenger accommodations and ticketing were accomplished in the larger central waiting room section. The bottom photograph is a view of the eastern section of the station that forms a beautiful belvedere, or gazebo, surrounded by columns supporting a conical roof of copper. The area offers a contemplative view toward a destination to New York City and a subdued place for a goodbye kiss. (Above, courtesy Brenda Adamski; below, courtesy Mary Melfa.)

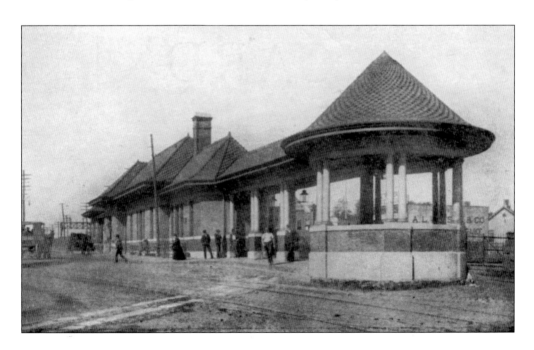

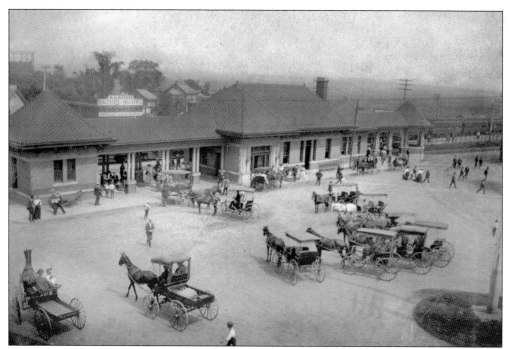

The location of the Rutherford Train Station was tremendously important, since upwards of 20 trains a day would pass through and four trolley lines sat at its doorstep. The original stop was a small station built in 1866 on land donated by Daniel Van Winkle. The photograph above reveals an afternoon rush hour in 1903 as liveries and carriages service the streams of departing passengers from a westbound train. Below, a 1905 dandy poses before a photographer as an early morning westbound train loads up. (Above, courtesy Virginia Marass; below, courtesy Ellyn Aronson.)

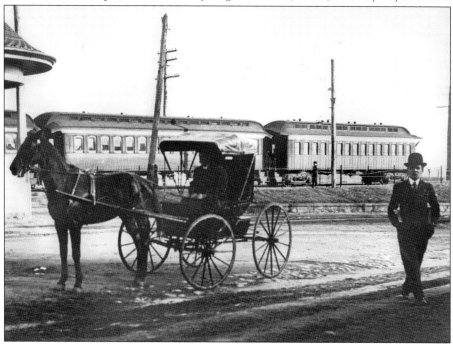

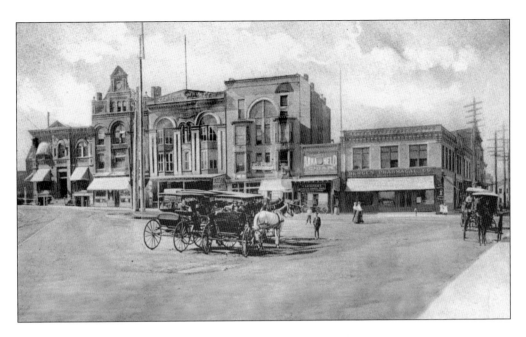

When arriving in Rutherford by train, what did one see exiting into Station Square? Until the 1900s, most buildings were lost to raging fires, but the Rutherford Volunteer Fire Department helped add some permanence, and soon a distinct skyline evolved. The 1904 Franz Huld photograph above shows the west side of the square with, from left to right, the Schafer Building and Annex, the General Market, Bottgers, Lemperts, and the Bergen Pharmacal Co. Below is a photograph 60 years later that marks the changing style of downtown architecture. To the left, the Schafer Buildings remain (now housing the Station Square Restaurant), Peoples Trust Bank has taken over the middle block, and the New China Inn resides on the right.

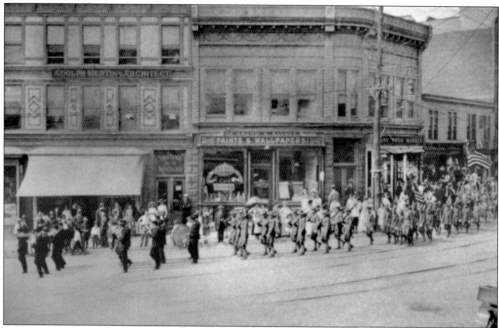

On the southeast side of Station Square, many buildings also fell to the ravages of fire. The Van Winkle real estate business continued in its same location, and the building remained mostly unharmed until the façade was renovated. The World War I parade (above) is seen turning the corner past the venerable McMain building at 9–11 Park Avenue in 1918. A wonderful aerial photograph (below) from the 1940s shows a fully developed Station Square now with a traffic circle for cars, a view of both sides of the square, and the Express Freight Office of the railroad station at the bottom. (Both, courtesy Mary Melfa.)

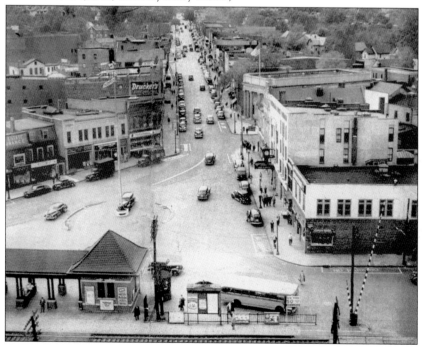

Just off Station Square, the original Union Hall on Ames Avenue (once called Union Hall Place) was the social hub of the community. Once standing on top of an adjacent hill, it was essential that it be physically moved down (possibly in the 1860s) to street level onto land donated by Daniel Van Winkle. As noted on an 1890 Sanborn map, it functioned as an early town hall for Boiling Spring and Union Township. Providing space for the start of many of Rutherford's houses of worship and social clubs, it seemed to be used by everyone at some point. As the social and governmental center of the Borough of Rutherford moved uptown and away from Station Square, its importance was soon forgotten. By the 1980s, it had become a retail space for Placidos Beauty School and Salon, but it was destroyed by fire in the 1990s. (Below, courtesy Colette Marino.)

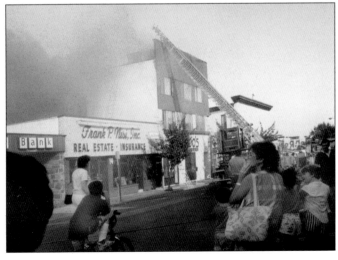

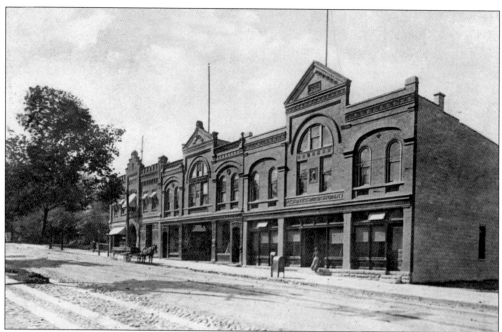

The dream of a centrally located Borough Hall, away from Station Square fires, train noise, and traffic, was somewhat fulfilled on April 3, 1900, when the borough took over what was once the Armory Building at 92 Park Avenue. The 1909 photograph above shows three separate six-bay commercial buildings, all built between 1894 and 1898. At that point, they housed (from left to right) Borough Hall, Mayor E.J. Turner's retail property, and the Rutherford Post Office. By the 1920s, a pediment existed over Borough Hall (below) and additional architectural details were added. Much of these façades remain, but the Borough Hall building was substantially destroyed by fire in 1970.

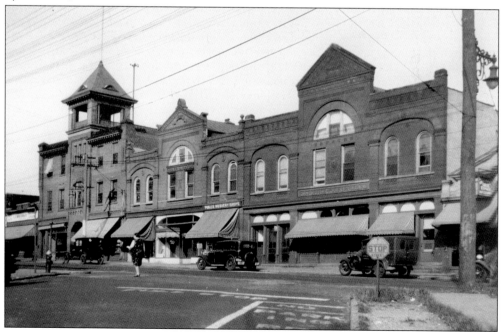

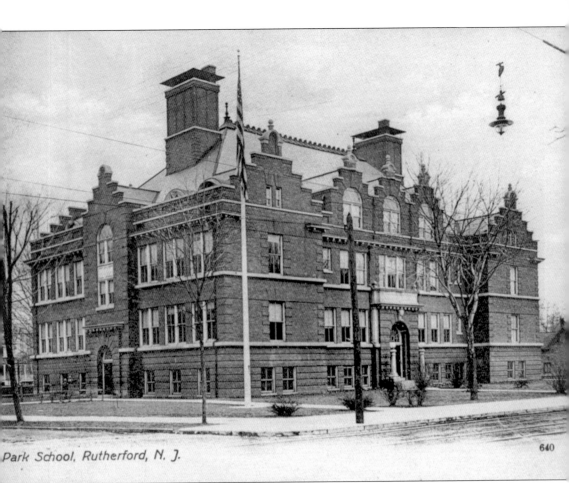

Park School, Rutherford, N. J.

640

An 1870 wooden structure was located at the original site of the Park School at 176 Park Avenue. The school-age population in Rutherford was exploding, so the building was demolished in 1900, making way for this new brick and limestone Park School designed by Belleville architect Charles Granville Jones. When it opened in 1901, it contained 15 classrooms, a 500-seat auditorium, a gymnasium, and offices for the board of education. But the student population still expanded, and much of the students were shifted into additional school buildings in the Rutherford district. As a result, Park School did not have a long history as the center for education in Rutherford. Through overuse and deterioration, this eclectic building was eventually condemned by the 1930s. (Courtesy Virginia Marass.)

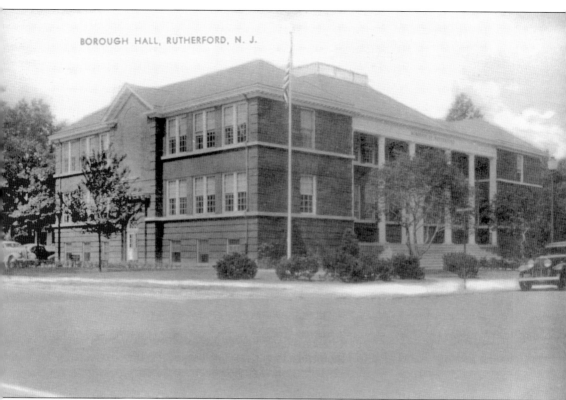

BOROUGH HALL, RUTHERFORD, N. J.

Condemned but not demolished, in 1937, the beloved Park School was being transformed. Local architect Louis B. Huesmann, along with his partner John Osbourne, was asked to draw up plans to convert the school into a modern Borough Hall. With the assistance of the Federal Works Progress Administration (WPA), they began by stripping off the very top floor over the gym. An entirely new main façade subdued the building's fussy, Gothic style with a more stately appearance. When visitors arrived at the Park Avenue entrance, they would address a wide staircase. Walking upstairs provided the feeling of being lifted onto an open porch framed by four two-story Corinthian columns and side pilasters. Huesmann and Osbourne preserved enough of the original character to allow the building to be warmly remembered as an original school. (Courtesy Mary Melfa.)

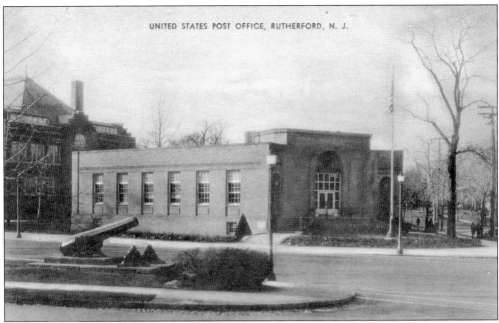

The top photograph contains five important Rutherford cornerstones. At left, the roofline of the old Park School is still evident before its removal in 1937. The Lincoln Park apex and the iconic cannon are prominent in the foreground. The Rutherford Post Office is shown completed by 1936. In 1935, the federal government chose Rutherford architect Edgar I. Williams to design this important building. It has a distinct, Romanesque Revival feel and welcomes people with an interesting curved front. The fifth cornerstone in this photograph is the small, light square next to the conical bush on the Park Avenue entrance to the building. It is the building's cornerstone and can be more clearly seen on the way into the building. The bottom photograph reveals the bones of the post office as bricklayers and stonemasons work to lay up walls early in the construction. The WPA also assisted in this project.

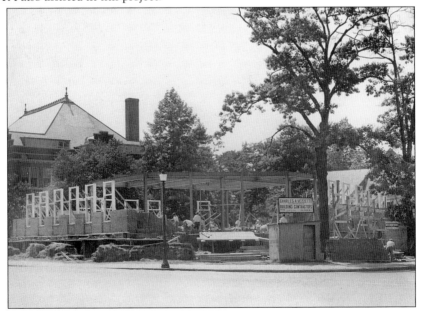

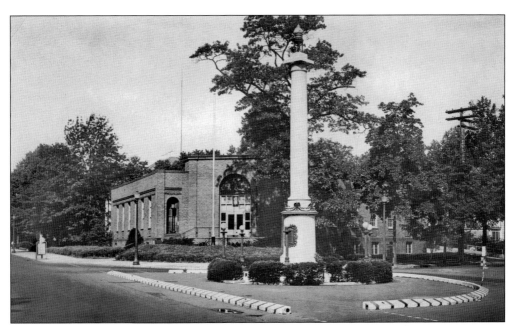

During the "War to End All Wars," Edgar I. Williams served as a Red Cross captain in Italy. The architect returned to his hometown and was moved enough by his experience to create the Soldiers and Sailors Monument, now known as the World War I Monument. It is a cast granite Romanesque column embellished by metal flourishes that include garlands and eagles. There are two metal plaques, one of which lists the 19 men who sacrificed their lives defending the United States. The column is surmounted on top by a glass globe in the form of a flame lit by an electric light. The architect repeated a French axiom to describe the vertical mass as "a finger pointing to Heaven." It is Rutherford's largest monument and freestanding sculpture. The dedication program from May 31, 1920, was drawn and lettered by Williams. (Above, courtesy Virginia Marass.)

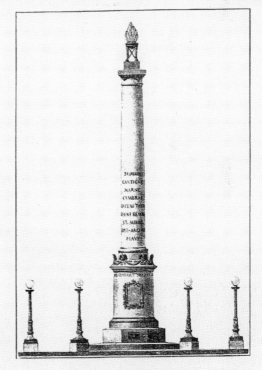

Soldiers' and Sailors' Monument

Erected in

MEMORIAL CIRCLE, RUTHERFORD, NEW JERSEY

DEDICATED MAY 31, 1920

In Honor of the Rutherford Men Who Died in Service During the World War

Rutherford's Free Public Library was established on January 4, 1894, and initiated by the Women's Reading Club of Rutherford with 784 books. At first it was housed in a second-floor space in the Schafer Building at Ames and Park Avenues. As the library outgrew that space, David B. Ivison donated the use of the former Presbyterian parish to house the collection. This original site was known as Ivison Hall and filled with books by 1901. In 1914, the library had over 7,000 books being shared by 2,177 members. By 1908, it was supported by municipal control. Just before World War I, architect Edgar I. Williams helped redesign the entrance and landscape. It would prove to be a prophetic assignment. (Both, courtesy Mary Melfa.)

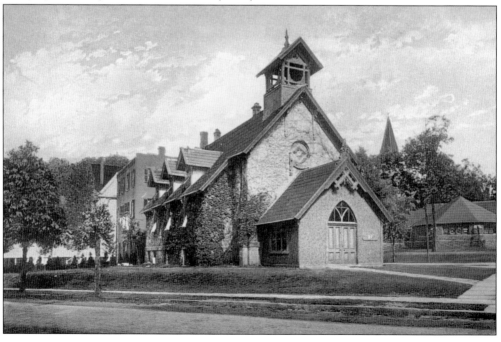

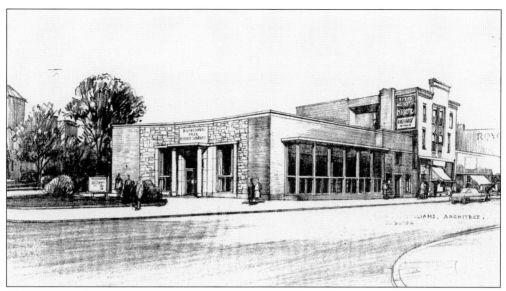

The Rutherford Public Library remained in the beautiful, but antiquated, Ivison Hall as it was repeatedly refitted for modern heat, electricity, and clerical space. In the 1950s, Rutherford sought out Edgar I. Williams to modernize the brownstone structure. Williams was an early historic preservationist and an avid user of the library. He devised several schemes to add more space, light, and office areas to the old building. Construction bids were offered, but after a time, they were rejected as being impractical. Williams returned to the drawing board, but he soon realized that only a new, modern building would be proper for the progress of his hometown. Shown is the architect's sketch of one of the final concepts. Note that the curved front of the new library is reminiscent of his 1935 design for the front of the Rutherford Post Office. Taken together, the two buildings seem to form cupped hands that surround and cradle the World War I Monument.

The women of Rutherford can be thanked for their diligence in providing the borough the restful Lincoln Park. What was once a tangled lot of trees and brush was leased in 1903 by the Rutherford Town Improvement Association, an offshoot of the Women's Reading Club. The Borough of Rutherford bonded for its acquisition and improvement and named the area Farrington Park after one of its previous owners. The name, however, did not stick. Two groups of veterans came together to request the park be renamed Lincoln Park. This was a compromise after moving the Lincoln Memorial, a plaque with the Gettysburg Address affixed on a large rock hauled from the Addison Ely Farm, from the park's prominent apex to its broad side on Park Avenue, facing the Park School. (Both, courtesy Mary Melfa.)

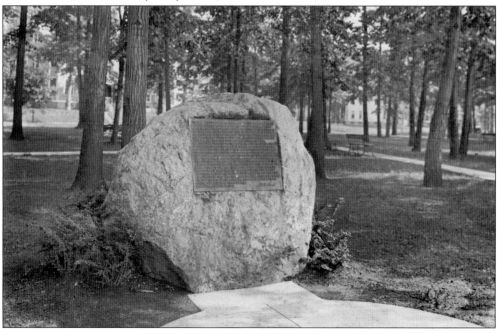

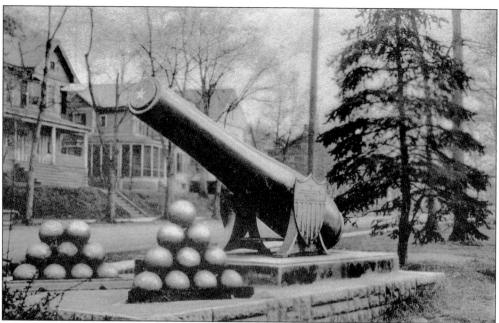

How many thousands of Rutherfordians have sat on the Lincoln Park cannon? Not many would know that this is one of the oldest public artifacts in the Borough of Rutherford. This noble, eight-inch Rodman cannon was made in 1861 at the Fort Pitt foundry in Pittsburgh, Pennsylvania. Its original use was in the sea defense of Fort Schuyler on Long Island Sound, New York. It was moved and dedicated as a war memorial in 1907 by the United Spanish-American War Veterans John Hilton Camp No. 3 U.S.W.V. Sharp-eyed readers will notice a missing cannon ball from the left ammunition stack in the 1914 photograph above. Sadly, over many years, countless "souvenir seekers" and just plain hooligans have pried off most of the original cannonballs until all that remained was one base layer. According to some, a few of these balls were seen rolling down Park Avenue at night.

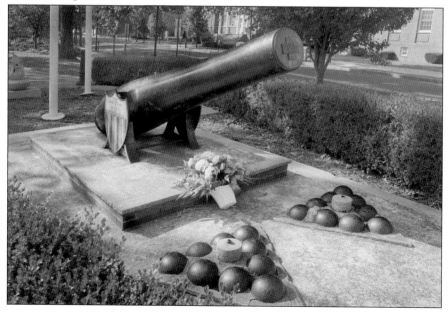

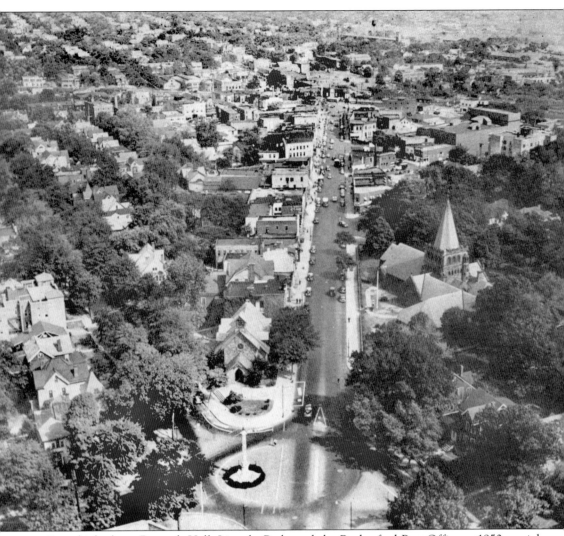

From high above Borough Hall, Lincoln Park, and the Rutherford Post Office, a 1950s aerial photograph (taken north on Park Avenue) reveals Rutherford's expanding downtown and the cornerstone of a civic center just starting to assume its place. The old library is still evident at the bottom, where Chestnut intersects at the World War I Monument, and the Presbyterian Church spire is on the right. This photograph illustrates the borough's second-most prominent intersection and also the radial nature of many of the town's oldest and most important roadways.

Three

ENLIGHTENMENT AND ENTERTAINMENT

It is surprising how many Rutherfordians do not visit New York City more often. Just eight miles away, it has always been an astounding source of entertainment venues and some of the finest museums, galleries, theaters, stadiums, and auditoriums in history. But why travel when within the comfort of one's own community is offered a local museum, numerous performing art offerings, movie theatres, a well-stocked library, and several stages for community performances? Although the Meadowlands is one town away and has been home to world class sporting events, Rutherford has always been a "walkable" town. Strolling to its numerous parklands to watch or participate in sporting events or just to reflect on a sunset has always been a pleasant, and mostly free, option.

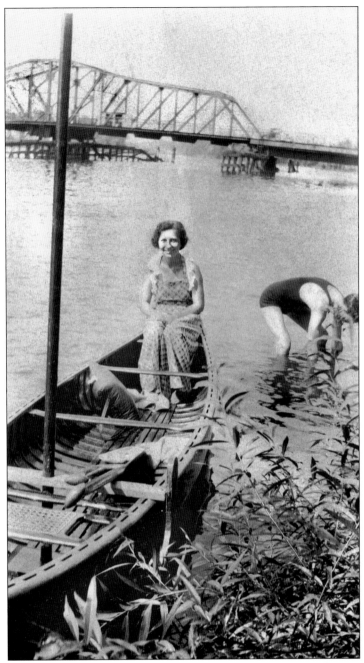

The Passaic River has been an essential water source since settlers first brought it to their mouths. Water has always surrounded this land. It has provided food, crop irrigation, sanitation, and then transportation and commerce. Beyond the essentials, it soon became a year-round source of recreational activity. People enjoyed boating, fishing, skating, and swimming up until the threat of pollution precluded some activities. In 1938, Florence and Conrad Schmehl lived close to the Passaic River and used it for recreational boating and exploration. They are pictured just south of the Rutherford Avenue Bridge as they dock on the river's east shore on a summer afternoon. (Courtesy Schmehl family.)

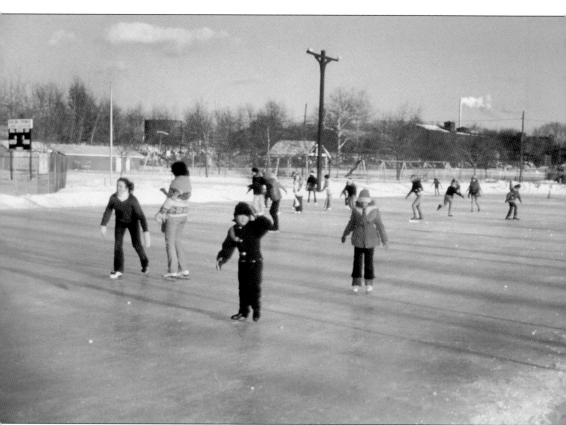

Rutherford recreation never stopped for cold weather. Because the borough contained numerous hills, the barricading and closing of steep streets like Washington Avenue between Carmita and Beech loosely regulated winter sleigh riding. Several generations remember the pleasure of winter skating at Memorial Park. When cold enough, the Borough of Rutherford would flood the parking lot adjacent to the little league field and invite the town to skate. (Courtesy Susan J. Schoepfer.)

The top photograph shows what has been called "Lake o' the Woods," "Swanwhite Park," or a natural recreational area more commonly known as Swan Lake. It was a natural, spring-fed lake actually situated in East Rutherford near the Standard Bleachery and the Erie Railroad. Once maintained by Bobbink and Atkins Nursery, it has been covered over for residential development. (Courtesy Anne McCormack.)

Sunset Park is one of many passive parks in Rutherford. Henry R. Jackson donated the hilly land in 1905. After World War I, the park was ringed by elm and maple trees, under which small plaques were embedded into the ground to commemorate Rutherford men who served in the war. (Courtesy Mary Melfa.)

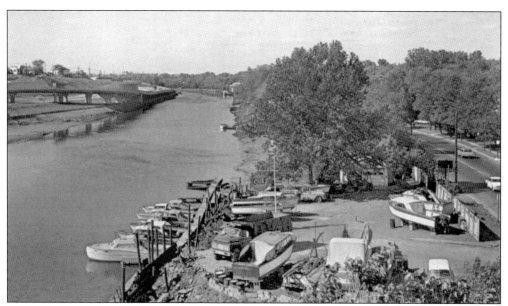

Boating was a strong attraction for many people in Rutherford. Living on a peninsula surrounded by water offers a lot of options for motivated people to enjoy the Passaic and Hackensack Rivers along with the meadowlands waterways. On the Passaic, the Rutherford Canoe Club was started as early as 1894. As seen here, the Rutherford Yacht Club established itself in 1927. Rutherford resident and master carpenter Clarence Hardin contributed to the raising of this private boat club in 1928. (Courtesy Mary Melfa.)

The boathouse was eventually sold and used as a marine business site, but it closed in the 1980s. In 1990, the Nereid Boat Club reestablished itself at the former Yacht Club location. When it leased the old "Chris Craft property," it brought to Rutherford a history of over 140 years as a rowing club. Today, the club has over 100 active members.

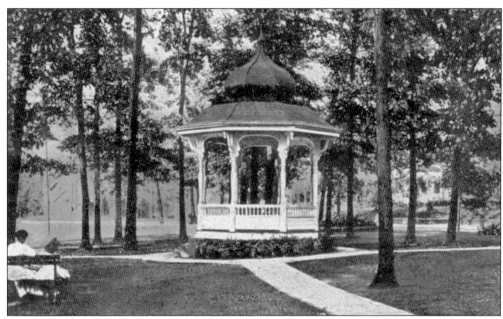

Lincoln Park was established in the early 1900s, and almost immediately, a park band shell was called for. Many used the centrally located Lincoln Park band shell (above) until deterioration and vandalism caused its removal. It was not until 1973 that the Hutzel Memorial band shell replaced it. William Hutzel was an outstanding music teacher and bandleader at Rutherford High School who suddenly passed away in 1962. For many years, it has been the home of summer concerts and the Rutherford Community Band, which is conducted by Rutherford High School teacher Richard Heller. (Above, courtesy Virginia Marass.)

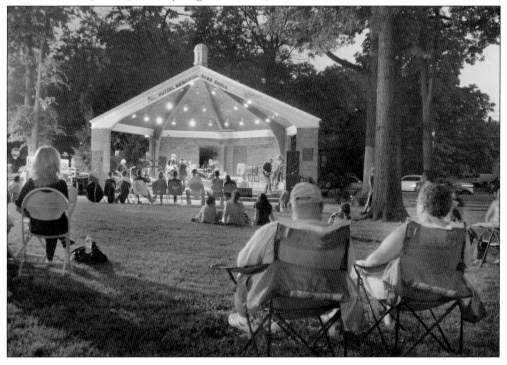

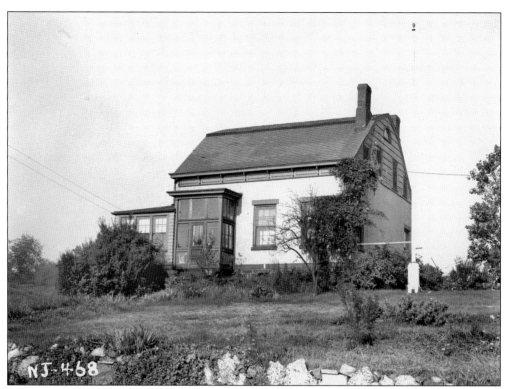

Generations of children have visited the Meadowland Museum at 91 Crane Avenue on the corner of Meadow Road. Begun as the Rutherford Museum in 1961, it was originally housed in the Sylvan School. Before it was a local museum, it was a farm residence and historically known as the John W. Berry House, or the Yereance-Berry House, as the history of the structure is somewhat unsettled. It has an estimated range of building dates from 1804 to 1818.

Besides the museum's cultural benefits, the building is historically and architecturally significant. It is one of the last remaining structures from the nascent Newark/Neck Road community of Boiling Spring. It is listed in the National and New Jersey State Registers of Historic Places. Both the photograph and the cross-sectional drawing are from the well-documented Library of Congress Historic American Buildings Survey.

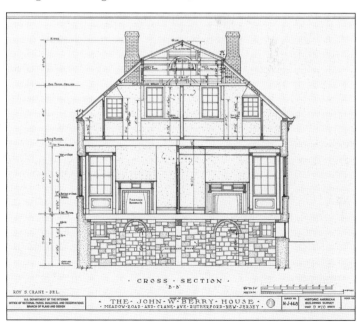

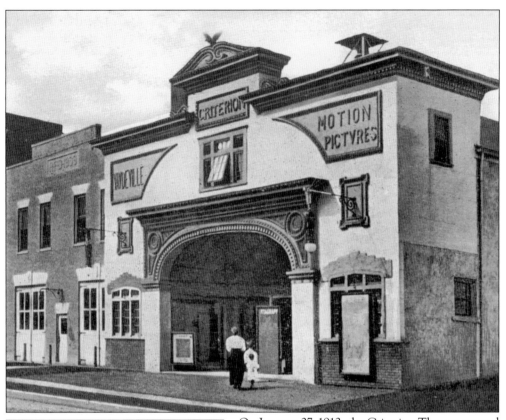

On January 27, 1912, the Criterion Theatre opened as Rutherford's first "legitimate theater." Located on Ames Avenue and just a few doors down from the original Union Hall (a "club theater"), the Criterion offered stage shows, vaudeville acts, and after a time, motion pictures. It closed in 1943 after a fire.

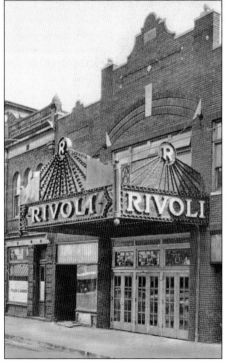

The beloved Rivoli Theatre opened to the public on a breezy night on April 22, 1922. The theater was built by Passaic architect Abe Prieskel, and the seating capacity was approximately 1,400. The theater featured a stunning crystal chandelier and a unique Wurlitzer pipe organ. Its original address was 9 Sylvan Street between Spring Dell and Glen. (Courtesy William Carlos Williams Center.)

By the 1940s, the Rivoli had quickly become the dominant local theatre for motion pictures and musical variety. Movie stars and celebrities made appearances while promoting films and products. It also was a community place that held many special events, especially around Christmas holidays. (Courtesy William Carlos Williams Center.)

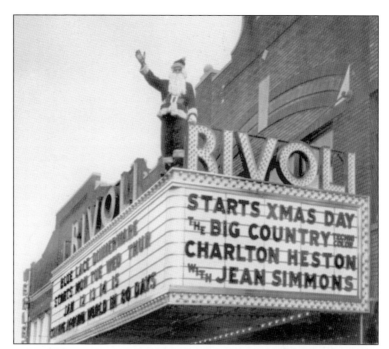

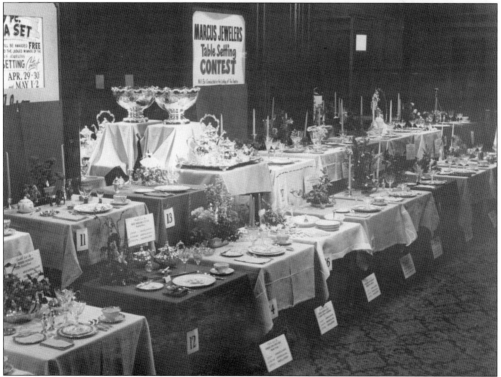

Promotions involved product giveaways and included Duncan Yo-Yos and YooHoo beverages with an appearance by Yogi Berra. Local retailers, just down the block on Park Avenue, also participated in promotions. This photograph illustrates a 1940s contest to win silverware and table settings from Marcus Jewelers. (Courtesy William Carlos Williams Center.)

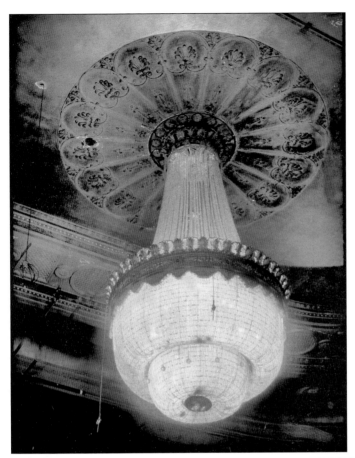

Sitting under the Rivoli chandelier could be a dare, as it seemed impossible to stay put. The massive structure was constructed with 60,000 Czechoslovakian glass pieces. The chandelier could be lowered by hand just to seat height for cleaning and bulb replacement. (Courtesy William Carlos Williams Center.)

This photograph is of the 1930s Rivoli interior with a view looking towards the stage area. Light is provided by an open door on stage left (reader's right) that leads to an exit to Spring Dell Avenue. Much of the theater was built on top of the underground Boiling Spring. (Courtesy William Carlos Williams Center.)

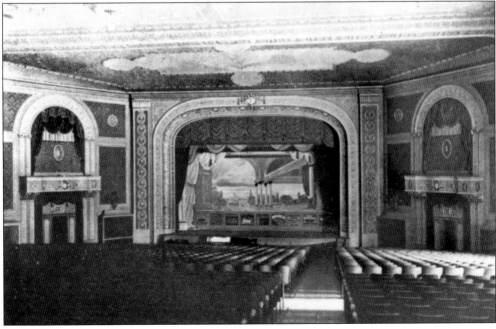

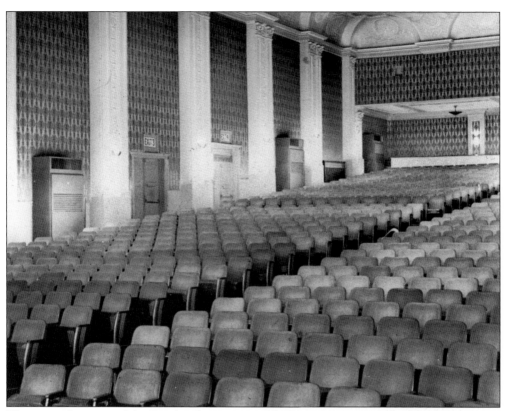

The original interior of the Rivoli—from the stage looking toward Spring Dell—is depicted above. After a lobby fire in January 1977, the Rivoli closed and its final fate was debated. Many people had a progressive idea to rebuild around the Rivoli Theatre to create a performing arts center. The construction photograph shows internal excavation to install smaller movie venues below grade of the larger space. The plan also involved the removal of the fire-damaged storefront and the closure of Sylvan Street to form a new plaza. The additional frontage could now be used to construct more performance spaces, a lobby, and a ticketing booth. (Above, courtesy William Carlos Williams Center; right, courtesy Carl Schlesinger.)

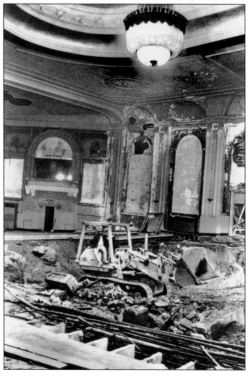

Community support was high as the William Carlos Williams Center for the Performing Arts opened in 1981. The new center was named for Rutherford's world-renowned poet and lifelong citizen. Some of the center's original supporters were Oscar Schwidetsky, inventor of the ACE bandage; the Marcus family of jewelers; and advertising executive George W. Newman. The top exterior back wall of the theater was repainted, proclaiming the new name, and would be visible to thousands traveling along New Jersey Route 17 (almost covering the ghostly "Rivoli-Rutherford" sign). The performing arts complex also sported a modern front that occupied a large part of the new Williams Plaza.

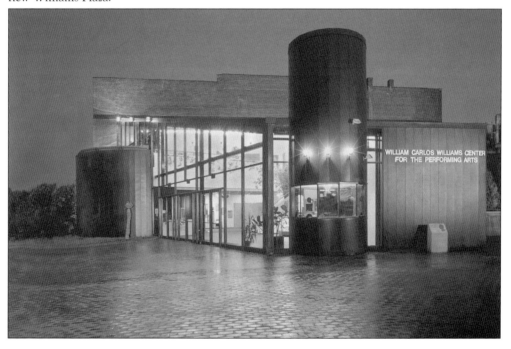

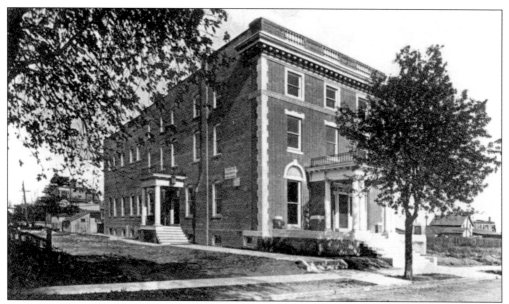

Social and civic clubs and associations have always played an important role in Rutherford enlightenment. In the last few years of the 19th century, the Benevolent and Protective Order of Elks, Lodge No. 547, was established as the first Elks Lodge in Bergen County. Early members included Luther Shafer and William "Theo" Muehling, a prominent cigar maker. The club grew very popular, and members sought out a permanent lodge site at 48 Ames Avenue. (Courtesy Mary Melfa.)

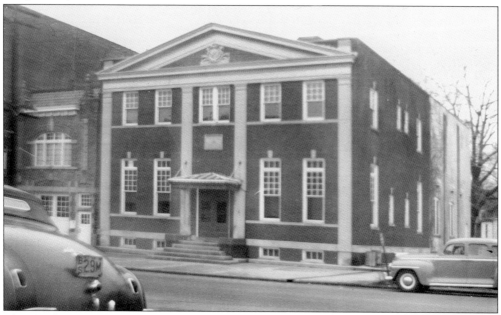

Chartered on December 9, 1881, the Masonic club of Rutherford was originally named the Boiling Springs Lodge No. 152 of the Free and Accepted Masons. This important organization states that they are interested in "making good men better." The cornerstone of their building was laid on November 16, 1912. This impressive building has been well preserved. (Courtesy National Masonic Hobby Club.)

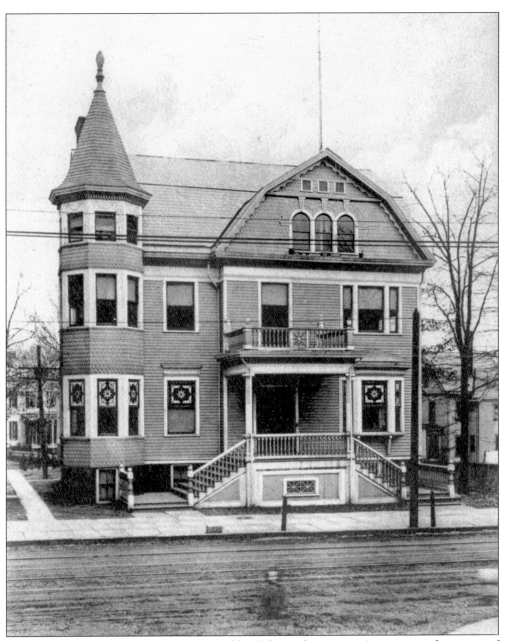

The original Union Club (later the Ely Building), located on Ames Avenue, was the center of town activity up until the end of the 19th century. This important social hub functioned as an early, all-purpose space for government activity, ecclesiastic gathering, and entertainment. As the churches found their own sanctuaries and borough activity moved uptown to the middle of Park Avenue, the all-purpose Union Club decided to move to 136 Park Avenue just across the street from the second site of the First Presbyterian Church. Many of Rutherford's social clubs reformed and recombined to fully occupy the new site of the new Union Club. On Monday, October 26, 1892, the doors were finally opened. But in the 1930s, the Union Club set its sights on occupying the vacant Iviswold castle. Unfortunately, after the move, the Depression cascaded hard upon the club's finances and membership dwindled.

Men were not the only social movers in the development of early Rutherford. In 1889, Rutherford historian Margaret G. Riggs began to organize the Rutherford Women's Reading Club within her home at 47 Ridge Road. Soon, their meetings were at the Union Club. Women's Reading Club members took part in the Town Improvement Association. Counted among the women's major achievements are establishing the Free Public Library and organizing the land for Lincoln Park. By 1924, the club was a dynamic force in town. Assuming a $15,000 mortgage, the club purchased the former Ivison carriage house at the corner of Montross and Fairview Avenues, and in 1928, they reorganized to become the Woman's Club of Rutherford. An iconic sketch by the noted artist Ferdinand Petrie provides a wonderful side view of the club. (Below, courtesy Ferdinand Petrie family.)

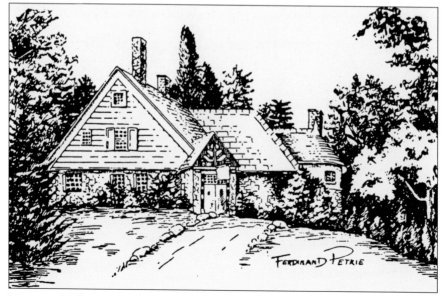

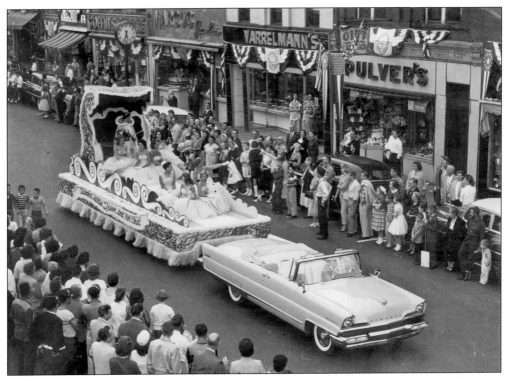

Rutherford's birthday is celebrated on September 21, the day in 1881 that the town officially began its separation from Union Township. In 1956, the town organized the 75th Diamond Jubilee, a weeklong series of events, displays, parties, and a time capsule interment in Lincoln Park. Lucille Dunn was chosen Jubilee Queen and was escorted by her Belles during a huge parade (above). As shown below, badges were sold as fundraisers to Rutherford's "Belles" and "Brothers of the Brush" (men who vowed to grow 1881-esque beards.) All Jubilee events and the borough's history were detailed in a Historical Program composed by Rutherford Historian James Hands. In 1981, the town celebrated its centennial with parades and an open picnic at Memorial Park. It would bury another time capsule in Lincoln Park and still another at the 125th anniversary. (Above, courtesy Mary Melfa; below, courtesy Vernon and Lucille Dunn.)

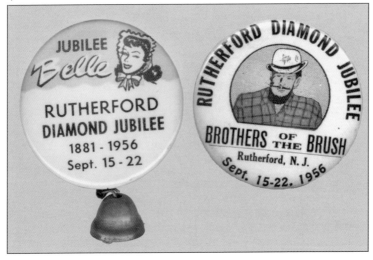

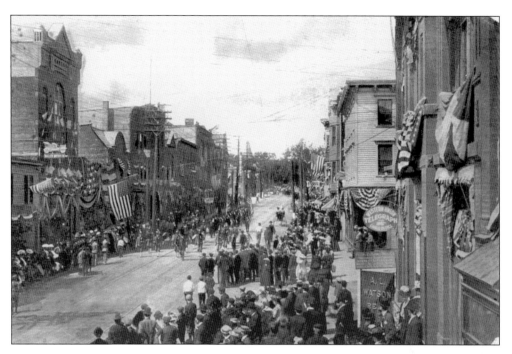

The Borough of Rutherford loves parades and through the years has found many ways to host them. As early as 1876, the village of Boiling Spring gathered to celebrate America's centennial on Daniel Van Winkle's property. These two photographs depict a 1907 Decoration Day parade as the Elks march by near Ames Avenue (above) and the procession's end in the Rutherford Depot, or Station Square (below). The crowd was estimated to be over 8,000 people. Many of Rutherford's Spanish American War veterans participated in this huge event. (Both, courtesy Virginia Marass.)

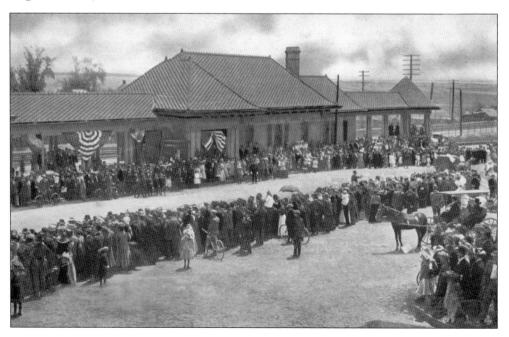

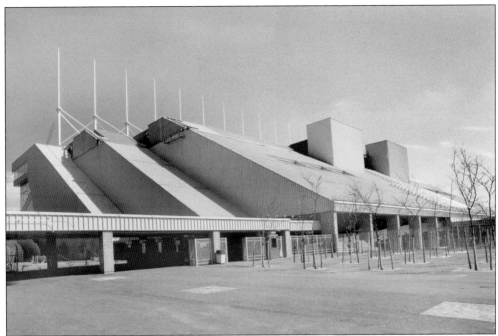

Since the 1960s, plans were bubbling to remediate, preserve, and of course profit from the marshy wetlands within and around Rutherford's borders. On November 30, 1972, a ground breaking took place to convert land just north of New Jersey Route 3 into what would become the Meadowlands Sports Complex. On September 1, 1976, the Meadowlands Racetrack (above) became the first venue to open. Giants Stadium (below) opened on October 10, and the Brendan Byrne Arena—the last of the complex's sports and entertainment structures—opened on July 2, 1981. Giants Stadium also became home of the New York Jets, and from 1977 to 1984, it hosted the Cosmos of the North American Soccer League and was a venue for the 1994 FIFA World Cup. The Brendan Byrne became the Continental Arena and was home to the New Jersey Devils and the New Jersey Nets.

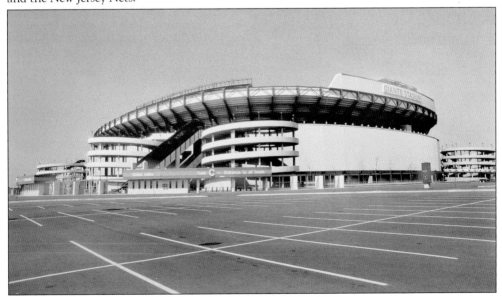

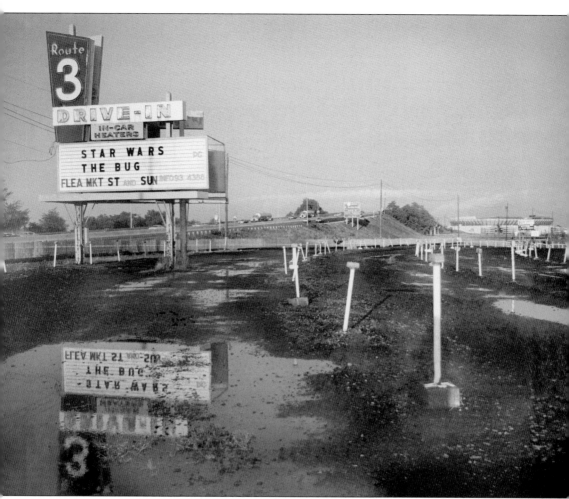

In 1955, the Route 3 Drive-In Theatre opened in Rutherford on the south side of New Jersey Route 3. It developed into a 400-car capacity while immersed in the mosquito-plagued "meadows." People paid upwards of $3.50 per ticket to park, light up a green-coiled "Pic," and hang an aluminum speaker on their window just to enjoy a movie in the great outdoors. Although the Route 3 Drive-In screen was surrounded by blinking radio tower lights and even the occasional brush fire, it was a wonderful place to bring an entire family (pajamas optional) or a special date. During the day, the New Jersey Department of Motor Vehicles occasionally used it as an inspection station, and on the weekends, the Route 3 Flea Market would set up.

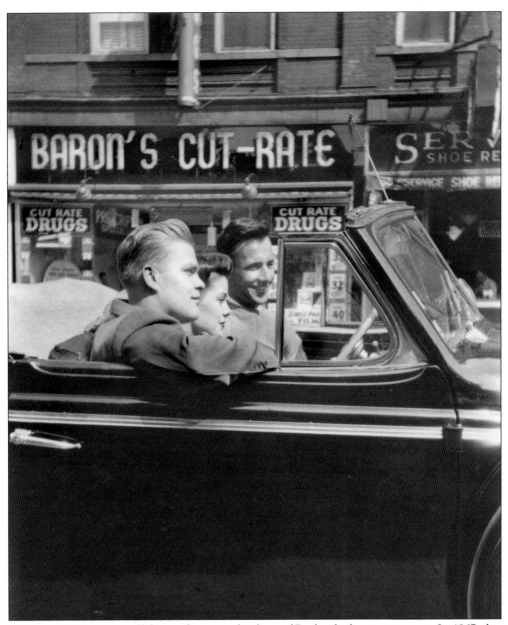

Cruising Park Avenue will forever be a popular form of Rutherford entertainment. In 1867, this roadway was originally conceived to extend north from the Rutherfurd Park Association near the Valley Brook Race Course (now a part of present-day Lyndhurst) all the way to the important Boiling Spring railroad station. After World War I, the use of automobiles and cheap fuel allowed leisurely drives in town as well as downtown window-shopping. Park Avenue in Rutherford was engineered, border-to-border, as a mile-long straight line. But a joyride did not need to go all the way from East Rutherford to Lyndhurst. A driver could start at Station Square, go just about half a mile south, loop around Lincoln Park (or the World War I Monument), and cruise back down Park Avenue almost all night long. This 1950s photograph reveals the enjoyment of driver Henry Jurkowski and his passengers while stopped just in front of Baron's Drug. (Courtesy Anne Rogers Jurkowski.)

Four

EDUCATION AND WORSHIP

Education and worship share strong links in human history. Early churches preached their own gospel while acquainting young students with rudimentary reading, writing, and arithmetic skills. Churches functioned as lecture halls, libraries, and recording offices for all of life's events from birth to death. Home schooling existed, but if there were no churches nearby, illiteracy was usually the norm. Independent schooling in the village of Boiling Spring (Rutherford) was first established within the small Dutch community on Newark Road (Meadow Road). There are many indications that an 1819 schoolhouse existed on the east side of the road near East Passaic Avenue. This schoolhouse was reestablished in 1852 as a one-room, one-story, wood-framed structure. This was a very progressive development for the area, considering that the nearest churches were in Second River (Belleville), Acquackanonk (Passaic), and Hackensack. Houses of worship were not formally established in the Rutherford area until the 1860s. Most of the 19th century churches in Boiling Spring began with humble meetings in the original Union Hall on Ames Avenue. Once the seed was planted, a sturdy tree of worship and social service took hold.

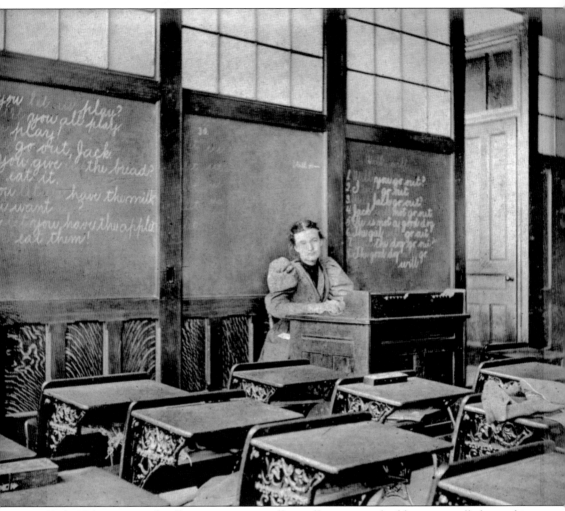

Early 19th century schoolhouses were generally small, one-room buildings centrally located in a community. Many times, the room was hot or cold, drafty and dusty, and sometimes all at once. Teachers, or "masters," moved from district to district, were paid a quarter-year term allowance per student, and were provided with room and board. In the Boiling Spring district, the school was supported by public subscription with some state support. In 1852, the school, located on Newark Road, was large enough to hold about 50 students of all levels. As the Boiling Spring community grew, a multi-room school was needed in a more convenient area of town. This 1908 classroom is thought to be within the centrally located Park School. Now a bit Spartan looking, at that time this classroom would have been quite modern in appearance. (Courtesy Mary Melfa.)

Above, the "Snow King Blizzard" paralyzed most of the eastern and southern United States and closed Rutherford's Park School (right) on Monday, February 13, 1899. Photographer E.R.F. Saunders decided to set up his camera just outside his residence at 184 Donaldson Avenue at Park Avenue and record the snowbound school. Below is an 1883 full-side view of the original wooden Park School. Built in 1870, it was the first modern, multi-classroom school in Rutherford and expanded in 1880 to hold more than 150 students. (Both, courtesy Mary Melfa.)

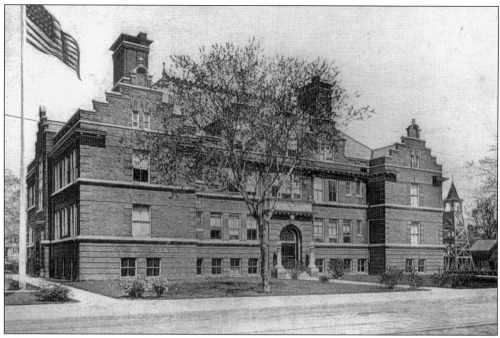

After the 1880 expansion, the original Park School was useful for another 20 years. Rutherford's school-age population was expanding rapidly, and other schoolhouses were being built in other locations in town. It was not long before the wooden structure was obsolete. At the turn of the 20th century, the Borough of Rutherford made the bold decision to replace the Park School with a new school, which would be constructed on the same site. Charles Granville Jones, an architect from Belleville, New Jersey, was asked to design the central school. He chose a brick exterior that would be three and a half stories with a ground floor entrance on Park Avenue and two side wings. The school would contain 15 classrooms, a 500-seat auditorium, a library, and a roof gymnasium. It opened in May 1901 and soon became a four-year high school. The 1906 photograph above shows the Park Avenue fire bell on the northern corner next to the school. (Below, courtesy Mary Melfa.)

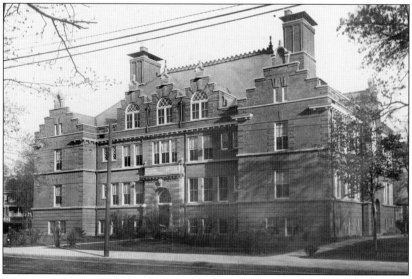

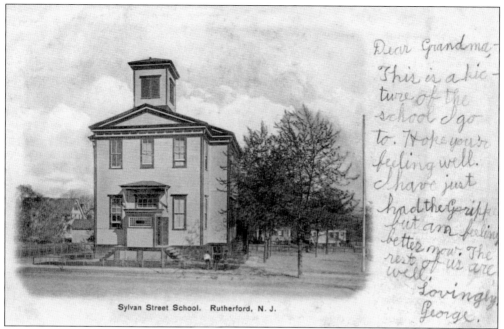

Sylvan Street School. Rutherford, N. J.

Dear Grandma—
This is a picture of the
school I go
to. Hope you're
feeling well.
I have just
had the Grippe
but am feeling
better now. The
rest of us are
well.
Lovingly
George.

There was no holding back Rutherford students (and students from other towns) as the borough sought ways to cope with the appeal of its quality of education. In 1889, another wooden school was constructed just a few blocks away from Park School. Sylvan School was built at the corner of Highland Cross and Sylvan Avenue and was intended to house primary grades within four classrooms. Pride in the old school is evident from the beautiful, 1909 postcard message sent from George to his grandma (above). The original wooden Sylvan School met the same fate as Park School when it was demolished in 1915 and replaced with a light-colored, brick-faced structure. When it reopened in 1917, it had a 320-student capacity and a basement gymnasium. (Both, courtesy Virginia Marass.)

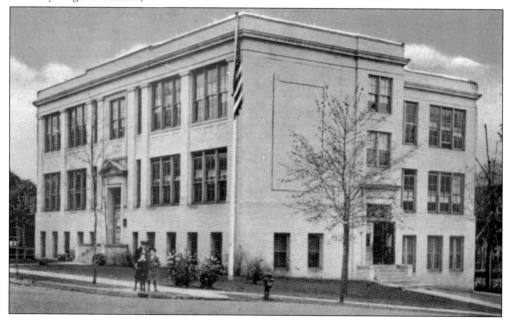

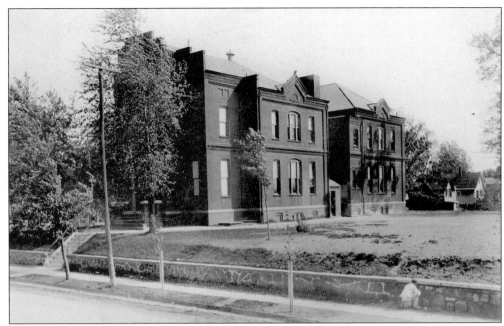

The first edition of the Union School was constructed in 1892 and opened on October 8 of that year. It contained five large classrooms and an assembly room. It was built close to Springfield Avenue on farmland once owned by the Cooper family, where a stream once divided the property. It was conceived as a brick structure, so it seemed that it might not share the same fate as the wood-framed Park School and Sylvan School. The 1907 photograph above shows Union School with a 1905 addition and a stonemason pointing up the last few sections of the brownstone wall that runs along Union Avenue. Below, the same angle shows the addition of a curious tower that may have housed a school or fire bell. Both images were credited to Wittridge, but Rutherford photographer George Garraway probably created them. (Both, courtesy Mary Melfa.)

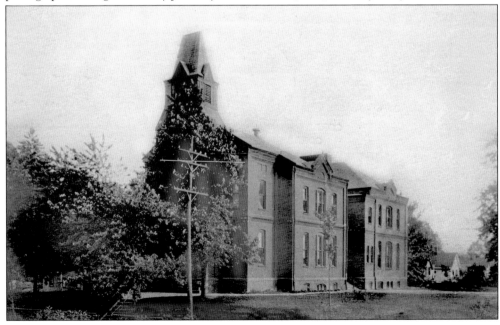

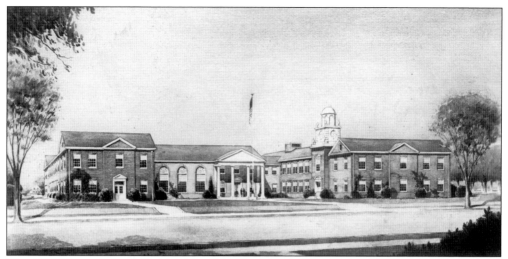

The 1892 Union School met the same fate as Rutherford's wooden schoolhouses and was torn down to make way for the new Union Junior High School. This photograph shows an artist's rendering of the new school plan for construction in 1926. The prominent Fort Lee architect Ernest Sibley was chosen for his previous experience in school construction in Trenton, Engelwood, and Leonia, New Jersey.

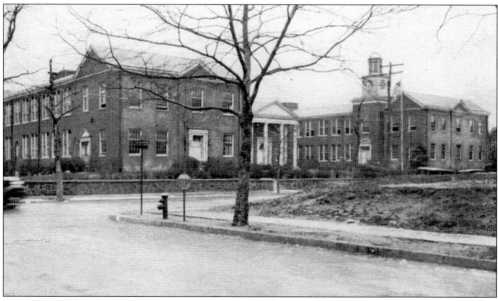

The Union School complex has many interesting architectural features. It is a U-shaped form that faces Union Avenue and is pushed back with large side wings parallel to Belford and Springfield Avenues. Overall, it presents a symmetrical, Georgian Revival style with a central, pedimented portico supported by four Tuscan columns and a clock-encased tympanum. On the west wing, a projecting block rises into a handsome square tower with an octagonal belfry. (Courtesy Brenda Adamski.)

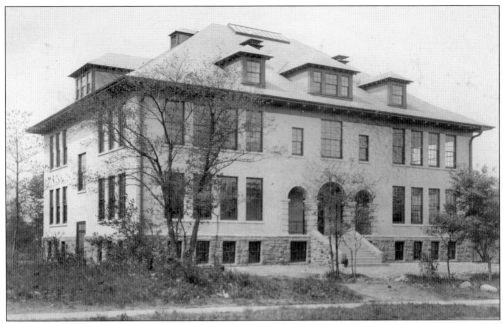

Pierrepont School was designed as another eastside school to accommodate kindergarten through sixth grade. The buff, brick schoolhouse was close to Ridge Road and really not that far from Sylvan School. This 1907 photograph by Wittridge shows a schoolhouse almost finished but still under construction.

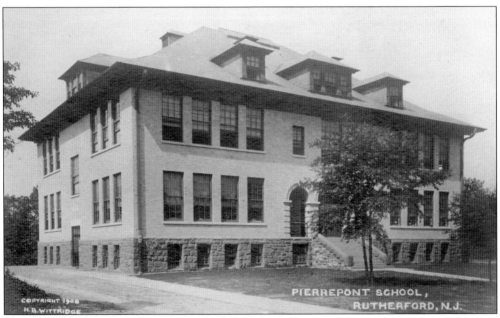

This photograph shows Pierrepont School fully realized and ready to open in July 1908. It is described as an 11-bay, two-and-a-half-story rectangular form with a Neoclassical design and Renaissance Revival detailing. The front (facing Pierrepont Avenue) has an arched porch slightly recessed and a wide roofline with bracketed eaves. (Courtesy Virginia Marass.)

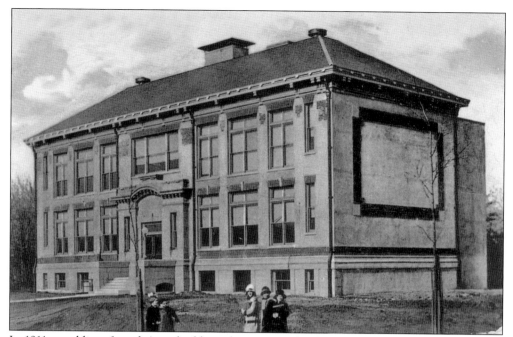

In 1911, a public referendum to build an elementary school on the Kip farm property south of Union Avenue was voted down. A year later, the original school plan was cut in half to form two smaller, separate neighborhood schools, and the referendum passed. Lincoln School on Montross and Vreeland Avenues was constructed in 1913 and has served the southwest corner of Rutherford. (Courtesy Virginia Marass.)

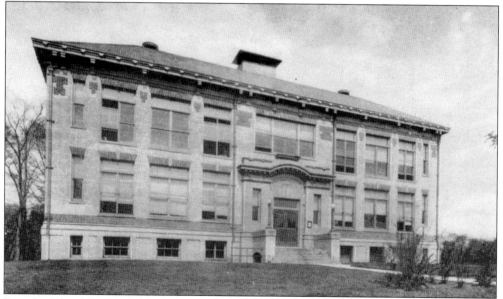

Lincoln School has a wonderful mix of surface materials, including early-20th-century stucco walls and a main body of light-colored brick and stone trim that works into curious lintel designs. The foundation is a cast-concrete block with a water table of common bond brick. The central entryway on Montross Avenue has cast-stone sidewalls and a three-light transom below an arched cornice. (Courtesy Virginia Marass.)

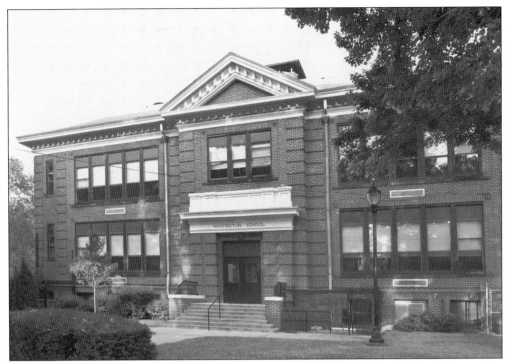

So what happened to the other half of the construction plan for a second school? It was also constructed in 1913 as Washington School at Wood Street and Washington Avenue. Lincoln and Washington were almost identical, as each school held 250 students. Although not as ornate as Lincoln School, Washington School was still a fine looking, two-story, T-form school with common bond brick and corner quoins in recessed brick. (Courtesy Virginia Marass.)

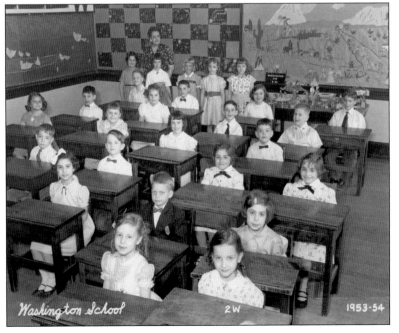

The 1953–1954 Washington School Class 2W happily smiles for a class photograph. The teacher was Miss Washington, and Miss Young was the principal at the time. Mary Sauter, the owner of this beautiful photograph, adds, "None of those teachers had first names, of course."

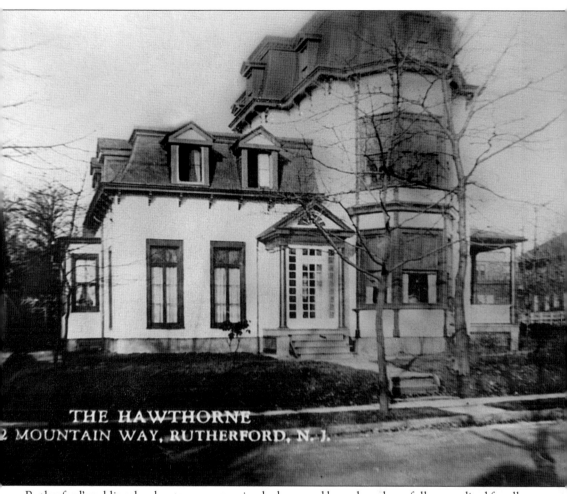

THE HAWTHORNE
2 MOUNTAIN WAY, RUTHERFORD, N. J.

Rutherford's public school system was growing by leaps and bounds and was fully accredited for all grades by 1928. There were also other educational opportunities within and around the borough. The Holsman Mansion, built in the 1840s on Union Avenue close to the Passaic River, became the Rutherford Hall Institute in 1891. This was an exclusive school for girls until the structure was destroyed by fire around 1902. The Riverside School was run by Mrs. Walter Henly and located in a large, private house at Pierrepont and Stuyvesant Avenues. It was organized in 1894 as a non-sectarian boarding and day school. In this photograph, one of Rutherford's more asymmetrical buildings, extant at 92 Mountain Way, was originally owned by New York City coroner Nelson Young. After he vacated the house, it became the Hawthorn, which started out as a residential school and eventually became a boardinghouse. (Courtesy Carol Hetzel.)

Since 1901, the Park School remained Rutherford's high school. Twenty years later, the school population had exploded while the structure rapidly deteriorated. Eventually, only parts of it were usable for a junior high school. The need for yet another school was a growing concern after World War I. It was decided that a new high school could be built on the southern part of the Kip farm property as well as from land acquired from Henry Kip. The high school was built in 1921, and its address was 56 Elliott Place. A capacity of 437 students entered the school in September 1922. The Elliott Place front was a long, horizontal, two-story form finished in a medium light brick with limestone trim. The back and sides of the school property stretched out and were perfect for recreational use and possible school expansion. (Both, courtesy Virginia Marass.)

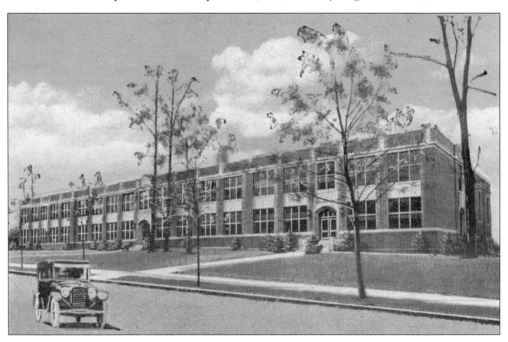

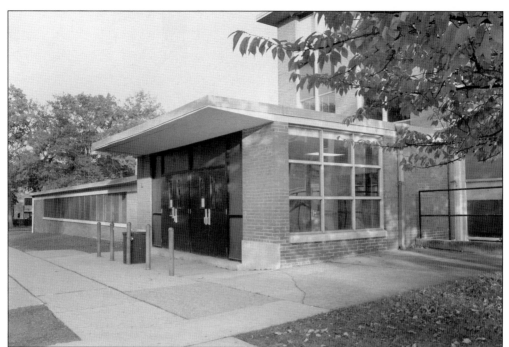

Rutherford had been trying to stay ahead of its growth in school population by shifting grade grouping around. Union and Pierrepont Schools were reconsidered as junior high schools in the 1920s. The first junior high school was conceived in 1909 as an easier transition between primary and secondary education levels. Rutherford used the eight-four years system, then switched in 1926 to a six-three-three system with the advent of the additional junior levels in Union and Pierrepont. All that changed when it was decided to build an addition onto the Mortimer Avenue side of the high school in 1957. Architects Micklewright and Mountford designed the junior high school. The modern style of mostly metal window walls with offsetting brick separations seemed to clash with the older high school masonry. The main entrance (above) was a large portico in red brick that led to a new gymnasium. The student handbook (right) was one of the first issued to arriving juniors in 1958.

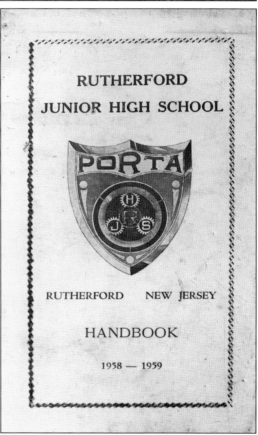

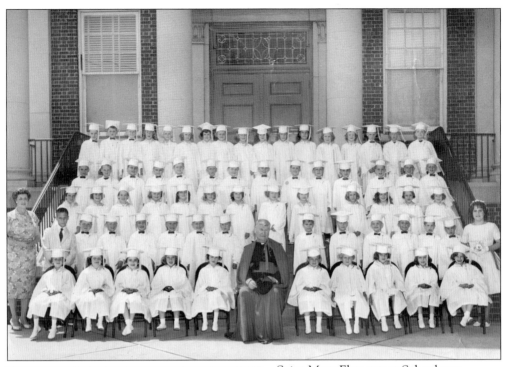

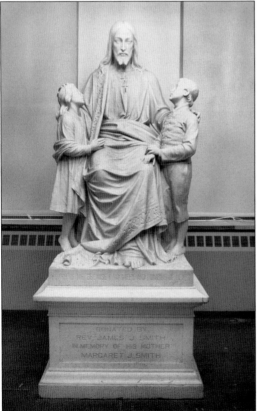

Saint Mary Elementary School was a natural outgrowth of the parish of Saint Mary Church and was promoted by its pastor, Fr. William F. Grady. On September 27, 1916, the first day of school, 100 students were admitted for all grades. The photograph shows a June 1963 Saint Mary morning kindergarten class with 67 graduates. (Courtesy Patricia Mariano Pasquale.)

The school's first principal was Sister M. Loyola. Fr. James. J. Smith succeeded Father Grady and made a donation to the elementary school of a memorable statue of Christ embracing a small boy and girl as his sides. It was placed at the top of the third-floor stairwell off the Chestnut Street entrance, and its inscription reads, "Learn of Me for I am Meek and Humble of Heart."

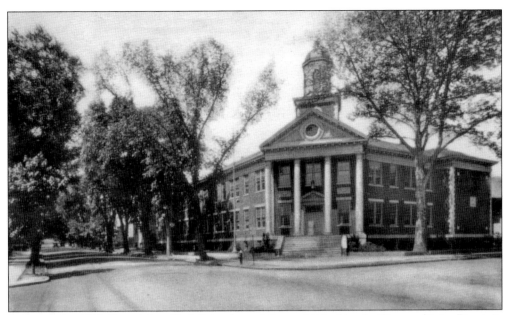

In September 1929, Saint Mary High School was fully established by the Sisters of Saint Dominic of Caldwell New Jersey, who provided the first course of instruction. In 1931, a grand high school building was being constructed and was finally opened on November 5, 1932. Much of the campus was expanded in 1959. (Courtesy Mary Melfa.)

Designed in a Beaux Arts style, Saint Mary High School is one of Rutherford's most impressive structures. The projecting corner entrance—at the corner of Ames Avenue and Chestnut Street—further expresses a V-form to the building. This entrance has four Corinthian columns and an eight-sided cupola on a square base that tops the roofline. Current enrollment is about 350 students. (Courtesy Mary Melfa.)

In his autobiography, *I Dreamed a College*, Dr. Peter Sammartino confessed that if not for a second martini, the largest private university in New Jersey may not have been founded. He recalled that in 1933, he "was sitting on the veranda of the house of my future father-in-law, enjoying two martinis. Had I just one, I doubt whether Fairleigh Dickinson College would be in existence today." Sammartino and his soon-to-be wife, Sally Scaramelli, were young, highly trained educators. While on Sally's porch at 220 Montross Avenue (above), they were reflecting on then-abandoned Iviswold castle just across the street. As they talked, they shared their experiences in progressive education and what they would like to accomplish in higher education. As their talk went on, it soon occurred to them that "the castle" might be a future home for a new college.

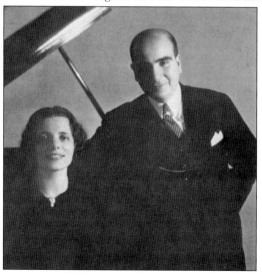

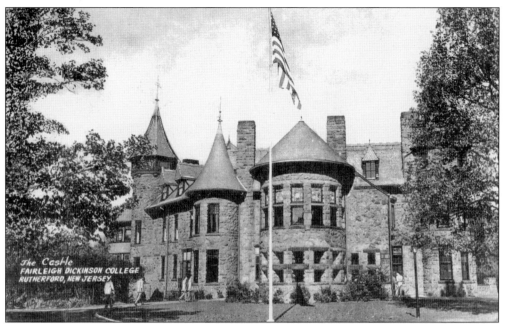

The Castle
FAIRLEIGH DICKINSON COLLEGE
RUTHERFORD, NEW JERSEY

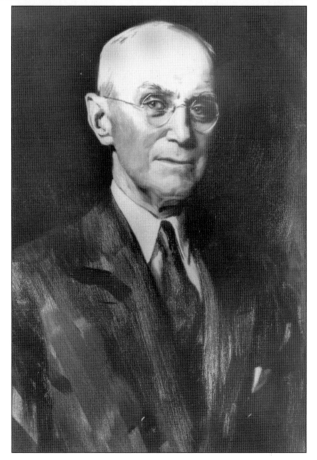

The dream of a college for the Sammartinos would actually materialize in Iviswold. Locally known as "the castle," Iviswold was built by David B. Iverson in 1888. The castle (above) was a residence from its inception up to a point when the Union Club of Rutherford briefly moved in. The club, however, lost residency in Iviswold when the Depression forced it to disband. By 1933, the property and improvements were owned by the Rutherford National Bank, which fortunately had the Becton Dickinson medical supplier as a client. As Peter and Sally Sammartino pursued their dream, they sought financing from the bank. With Fairleigh S. Dickinson's financial assistance, the Sammartinos soon controlled the 36-room castle and 12 acres of property for a surrounding campus. They chose to name the two-year junior college in honor of its chief benefactor, Fairleigh S. Dickinson (right). The college officially opened on December 3, 1941.

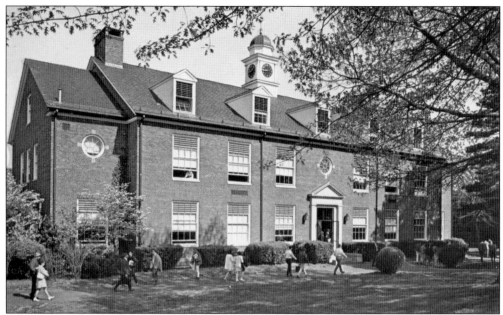

On September 12, 1942, Fairleigh Dickinson College opened with 153 day and evening students. When World War II ended and soldiers returned, the school really took off. It soon became obvious that the college could not be contained in just the castle. In 1945, the Sammartinos sought out Rutherford architect Edgar I. Williams to design their first construction project, Becton Hall (above). The building was named after Maxwell Becton, another of the college's benefactors and founding partner in Becton Dickinson. The style is Colonial Revival and the exterior is common bond brick. A centered square belfry with a four-sided clock was added in 1967. When the Hesslein Textiles Building (below) was erected, only enough money was available to complete the exterior, but the college faculty and students voted to finish the interior with their own labor and commitment. (Both, courtesy Virginia Marass.)

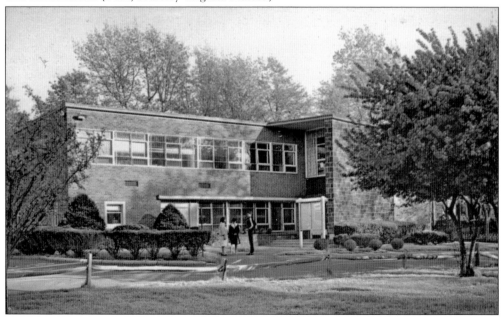

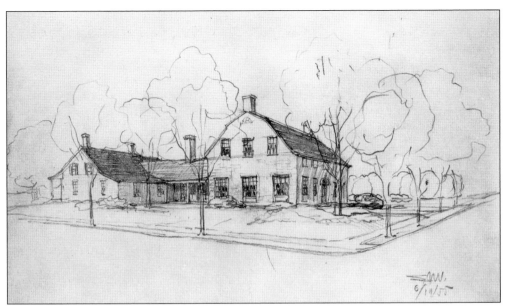

Innovative architecture and historic preservation coexisted quite well in Fairleigh Dickinson. As an example, when Becton Dickinson needed to expand, the Sammartinos considered the demolition of the Ackerman-Outwater House, an outstanding Dutch Colonial stone structure on their property that faced Hackensack Street in East Rutherford. Instead, they again turned to Edgar I. Williams to find a way to preserve the building. Williams proposed to move the structure, stone by stone, and join it to the existing Yereance-Kettel House (also known as the Kingsland House) at 245 Union Avenue. The architect's sketch (above) shows the Ackerman-Outwater structure on the right side connected to the wood-framed Kettel House (left) by a short enclosed walkway. By 1957, the two structures were successfully joined, and classes were scheduled for both buildings.

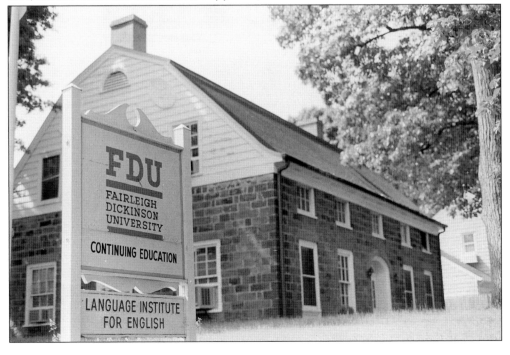

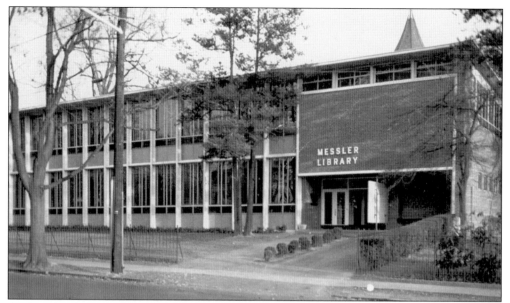

As the school grew, innovative architecture and progressive education became standard. By 1948, it was a fully accredited, four-year college and established a collegiate sports program with its own Rutherford gymnasium in 1950. In 1956, the college achieved university status. During the 1950s, it acquired two additional campuses. The Teaneck Campus (1954) introduced the first dental school in New Jersey, and the Florham-Madison Campus (1957) was centered on the Twombly Estate in Madison. In Rutherford, the university added the Messler Library (above), which became a New Jersey State Library Repository, and Sammartino Hall (below), designed by Ronald Wank of Wank Adams and Slavin, a New York City architectural firm. After its construction in 1966, it would be locally known as the "Round Building." Finally, in 1970, two large dormitories were added, which would be the last structures built on the Rutherford Campus. In 1993, Fairleigh Dickinson abandoned its Rutherford campus and sold it to Felician College in 1997.

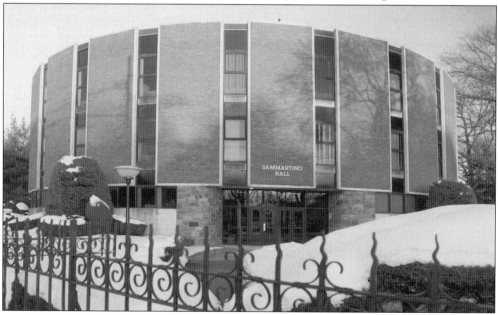

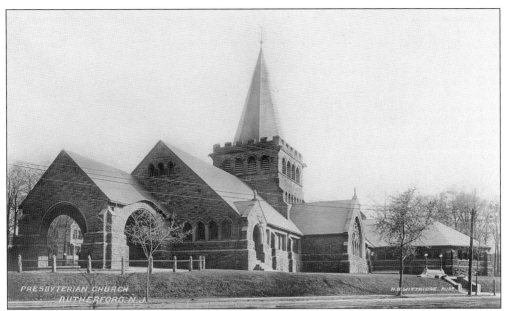

Until the middle of the 19th century, most formal religious services were still held in Aquackanock, Hackensack, or Second River (Belleville) churches. In 1859, Floyd Tomkins commenced a Union Sunday School when services were first held in the original Union Hall on Ames Avenue. This common structure actually gave birth to many Rutherford congregations. In 1863, a petition was created to establish a Presbyterian congregation. Soon, a plot of land was obtained from David B. Ivison at Park Avenue and Chestnut Street to build a Gothic-style church (see page 34.) By 1869, a cornerstone was placed, but all too soon, the humble church became too small to house the growing number of congregants. A large triangle of land was obtained just across Park Avenue, and in 1888, construction began on the new church. When it was finished on March 27, 1890, it would become a stunning landmark for the town. (Both, courtesy Brenda Adamski.)

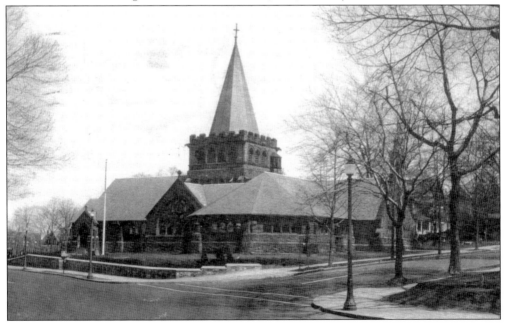

The history of the Grace Church Episcopal started with 1867 meetings at the Rutherford Park Hotel (once the Rutherfurd family mansion) on River Road in what is today's Lyndhurst, New Jersey. This point was halfway between the village of Boiling Spring and Christ Church in Second River (Belleville). A committee was assembled on March 4, 1869, to formalize a parish in Boiling Spring village. Worship was held in the Union Club. Floyd Tomkins, the owner of Hill Home (a large estate soon to be redeveloped and renamed Iviswold), would extract a parcel of his own land that faced Passaic Avenue. Tomkins, along with George Woodward and William Ogden, would help secure financing to employ architect William Halsey Wood to create a brownstone edifice with a central crenellated tower. The cornerstone was laid in October 1872, and in 1911, a parish house was completed. (Both, courtesy Mary Melfa.)

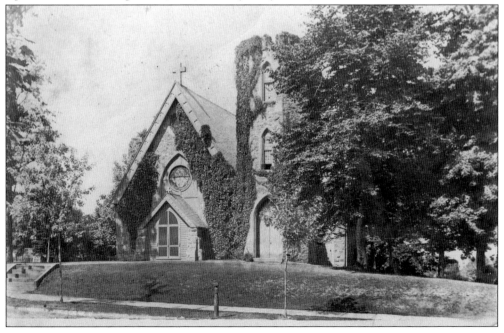

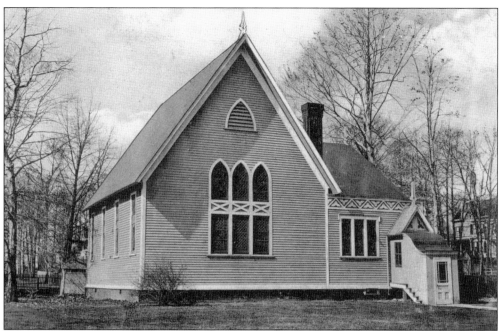

Another post–Civil War church was organized on October 1, 1869. About two dozen Baptist followers had been meeting in Union Hall and at the home of Benjamin Yates. Once a decision was made to build a church, Deacon Richard Shugg donated land at Highland Cross and Park Avenue. The cost was $2,700, but much of the construction costs were shared by the church's prominent members, Yates, architect E.C. Hussey, and builder Samuel Hinks. After 15 years, hardship befell the congregation; they eventually disbanded, and the structure was demolished. A determined group, they reformed first as the Pilgrim Baptist Church and then, in 1887, as the Rutherford Baptist Church (above). A new wooden church was designed by Hussey and opened on January 26, 1890. The church was set back enough to accommodate a growing congregation. As seen below, by 1917, an impressive Gothic Revival stone addition was added closer to the street that also covered the original site.

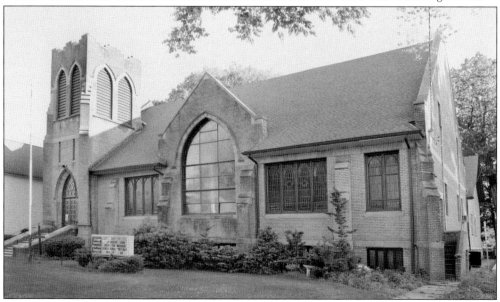

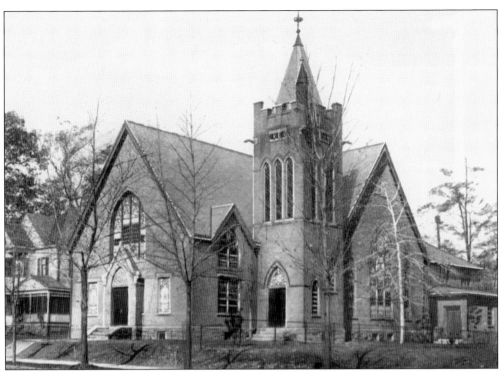

In 1869, Methodist ministers Rev. A. Craig and E.V. King from Passaic were called to form a congregation in Rutherford Park. A charter was drawn on December 15, 1870, for the Park Methodist Episcopal Church. Initially, meetings were held in the busy Union Hall; it took another 10 years and some reorganization to construct a building across the street. The land was donated by Mary E. Ames of New York City. As was the case with other structures in a growing town, the church proved to be inadequate to house the increasing number of worshipers. A new site was found, and architect Taylor Corwall started work on a new edifice in the fall of 1895. The final dedication was on April 12, 1896. The 1911 photograph above shows the completed West Passaic Avenue church with a tall steeple, which was capped after storm damage. Wonderful upgrades have been made to the interior (below) of the church, and the name was changed to the Rutherford United Methodist Church. (Both, courtesy Rutherford United Methodist Church.)

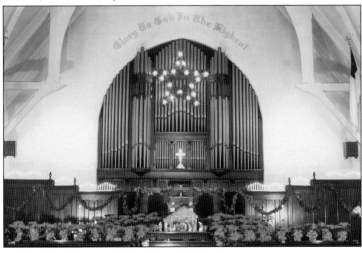

Greetings from
RUTHERFORD, N. J.

Members of the Bell family were prominent Rutherfordians who owned property all over town. The Henry Bell home was located approximately where the Congregational Church stands today. Within his home—actually, in his parlor—was where the Unitarian Church was formed. Twenty-two people came together to practice a more open form of Christianity on December 22, 1891. The interested parties included the Luces, Danheims, Burrows, Beaumonts, and the William George Williams family. The congregation asked Bell for his help in acquiring a plot of his land at 70 Home Avenue. By December 15, 1892, a humble wooden structure with a large steeple was completed. Former mayor Oscar F. Gunz was the probable architect in charge of the project. The Williams family, including sons William Carlos and Edgar Irving, were regular members, as their mother was a frequent pianist and their father, William George, was the Sunday school superintendent. The Rutherford Unitarian Society dedicated the church as Church of Our Father.

The evolution of the Congregational Church in Rutherford had many twists and turns. In 1878, Rev. Dana Walcott had retired from the Rutherford Presbyterian Church and formed an association known as the Congregational Church of Rutherford. In 1896, the Bookstaver and Hollister families established a plan to erect a church in the West End of Rutherford on Belford Avenue to be called the Emmanuel Chapel Society of the First Presbyterian Church (above). On December 19, 1897, a cornerstone was prepared for this structure, which was designed by architect Herman Fritz. As seemed to be the case in Rutherford, however, this structure proved to be too small and was replaced by a church in 1911 at Carmita and Washington Avenues (below).

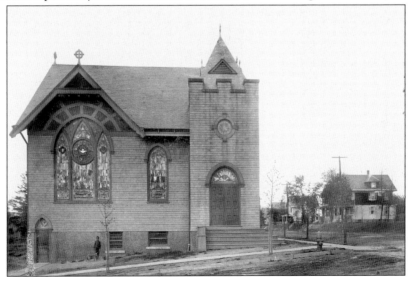

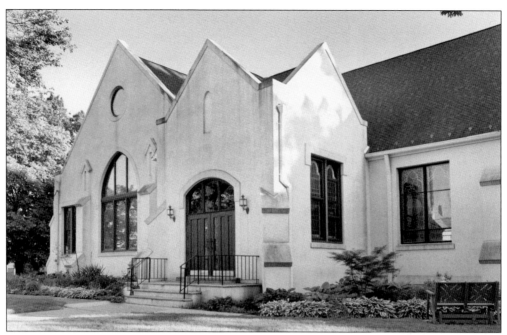

It seemed that the Congregational Church was being tested. Their pastor, Henry Prentiss, had passed on, and a 1923 fire destroyed their Carmita Avenue structure. Without a place to meet, they looked toward a new pastor, Rev. Norman Pendleton, for guidance. Quickly they found a new building plot on Union Avenue at the Bell estate and hired architect Dudley S. Van Antwerp to design a new church (above) to be dedicated on October 26, 1924. Throughout the church's history, the faithful have found a way to rise above adversity. Over the years, many Rutherfordians look to the church's lawn signs (below) for daily inspiration.

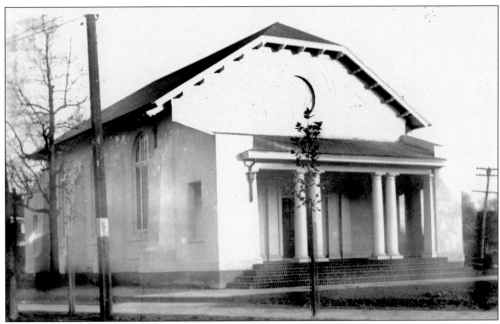

First Church of Christ, Scientist was first promoted around the beginning of the 20th century with its first services held November 18, 1906, in Ruchstuhl Hall on Sylvan Street. A small church (above) was erected in 1912 for the congregation on the corner of East Newell and Park Avenue. As the church grew in size, it contracted one of its own members, Frederic Lansing, to design a new home at 68 East Pierrepont Avenue. The cornerstone for that church was laid on August 5, 1928, with its first Sunday service in 1929. Membership slowly declined, however, and by 1998, the church voted to end its 90-year presence in Rutherford. The brick, Neoclassical/ Georgian style building is now being filled by the Noor Va Danesh Iranian Muslim Association of the Eastern United States. (Above, courtesy Mary Melfa.)

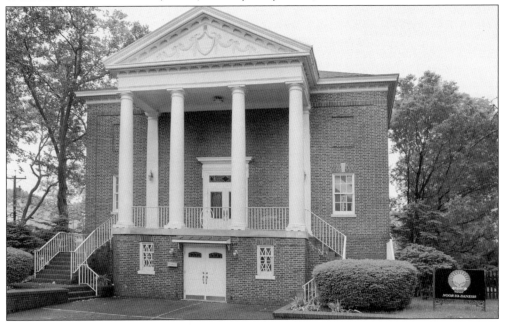

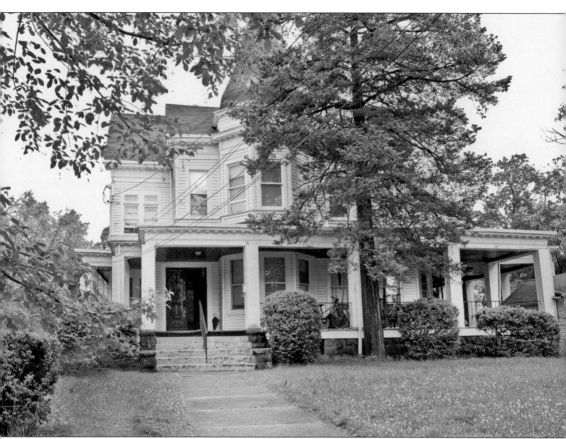

Temple Beth-El started out as the 1890s home of the Rudolph and Hannah Dannheim family and was designed by Rutherford architect Herman Fritz. When the Dannheim family vacated the house, Dr. Benidict Willis's family took possession of it in 1923. Rutherford retailer Arthur Drucker and Jack Terkowitz were members of the Jewish Center of South Bergen located in East Rutherford. During the 1950s, the center had been seeking a new home for a synagogue in the Borough of Rutherford. In 1953, the men heard that the Willis property was on the market and made an offer. The Willises were a religious family and understood the need for a new home for the faith. They sold the residence to the Jewish Center in July, and Rutherford's Temple Beth-El was born. The center then hired Rutherford architect Andrew Lewis to design a modern addition that would accommodate classrooms, a gymnasium, and a conference center. The east wing was dedicated on February 22, 1955.

Early members of the Mount Ararat Baptist Church first sought fellowship in 1893 by meeting in their homes. The church was organized in July 1896 and held those first worship meetings in the venerable Union Hall. The congregation grew and sought larger space. It was not long until plans were made to establish a building specifically for this Baptist congregation. By 1902, extensive plans were being formulated to obtain a large plot of land on Elm Street. The church members found the funds to erect a small building and were able to dedicate it on February 20, 1903. In 1919, the present structure was erected. Rev. Ray Frazier has been the spiritual leader of this church and was a popular Rutherford council member.

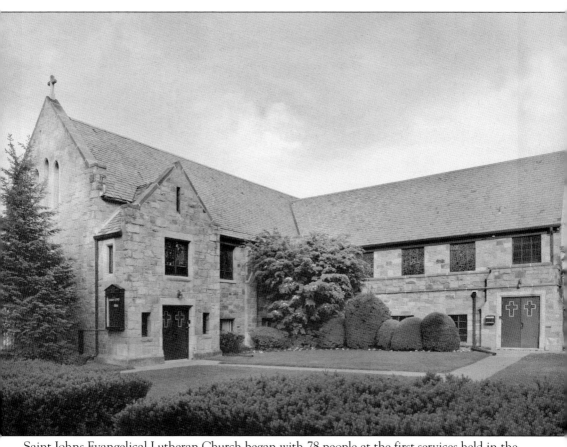

Saint Johns Evangelical Lutheran Church began with 78 people at the first services held in the Masonic Temple on October 31, 1926. The first pastor was Rev. Edwin Knudten. In April 1927, a plot of land was secured at the corner of Mortimer and Fairview Avenues, and construction began on April 6, 1930. The church was constructed of light-colored ashlar masonry and was dedicated on September 28 of that year. The Gothic Revival style accents this impressive neighborhood church set on the northeast corner of Fairview and Mortimer Avenues. The building also welcomes friends by a projecting side-gabled bay that leads onto a wide lawn. A 1955 addition almost doubled its size, and the church now follows an extended L shape. The vast majority of the church's beautiful, stained-glass windows are the work of Rutherford artist Gordon Henderson.

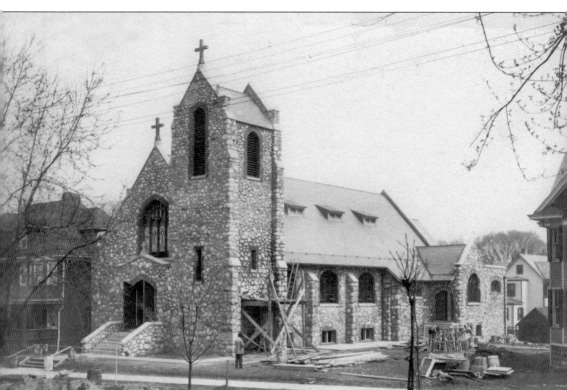

Saint Mary's Roman Catholic Church has roots that began in 1872 at St. Joseph Roman Catholic Church in Carlstadt. Previously, Catholics who lived in Rutherford and wanted to hear mass had to cross the Passaic River to St. John's in Paterson (1854), St. Nicholas in Passaic (1865), or St. Peter's in Belleville. In 1908, a group of people met to establish a new Catholic church. The first pastor appointed was Rev. William Grady, and the first mass was held at Rutherford's Borough Hall on Easter Sunday, April 16, 1908. H.A. Wiseman designed a new church that used rounded stone to establish an English Gothic façade. As the cornerstone was slipped into place on October 3, 1909, the parish was renamed Saint Mary's Roman Catholic. The edifice of the church was completed and dedicated on April 10, 1910. In time, a larger, more modern church was built adjacent to this and the original church was demolished in the late 1990s. (Courtesy Mary Melfa.)

Five

RUTHERFORDIANS AND THEIR HOMES

Many people are amazed when told that 12 generations of the Van Winkle family, direct descendents of Rutherford's original 17th century settler Waling Jacobs, have remained within a mile or so of his ancient homestead. But then, many Rutherfordians are perplexed when even one of their neighbors moves away from town. The Borough of Rutherford has always exerted a strong attraction to anyone who has known its charm. It is so close to the center of the universe of New York City, but it is still a small town close to the heart of its citizens. The history and diversity of the people who have lived in "the Borough of Trees" is extensive. Volunteerism has always been high, and social involvement is almost mandatory. Many Rutherfordians have had ample resources to live anywhere in the world, but decided to stay and help develop their community through business, art, and government. Of course, many Rutherfordians have physically left and have not looked back, except for that occasional tug to their heart from a place they once loved.

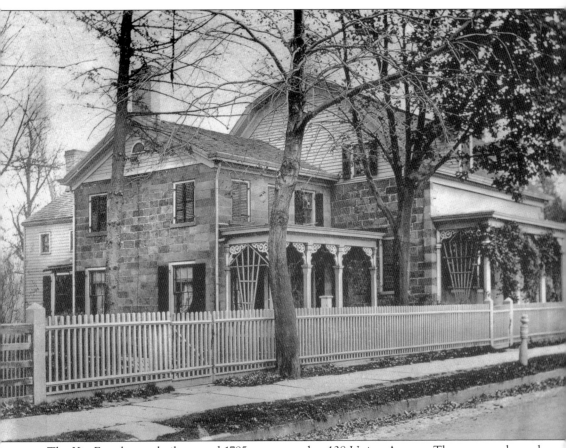

The Kip Farmhouse, built around 1785, once stood at 138 Union Avenue. The stone and wood house anchored one of the last of the large farms that remained in Rutherford until its owner, Peter H. Kip, died in 1920. Through banking and real estate, Peter Kip became one of the wealthiest men in the area. During the decade after his death, the house was demolished and the farmland estate was consumed to become land for the high school complex and a residential neighborhood bordered by Home Avenue, Elliott Place, Wood Street, and Union Avenue. The Favier and Colabello building company started many of the Colonial Revival homes in 1926. The neighborhood was designated in the 1981 Bergen County Historic Sites Survey as the Kip Farm District.

Peter H. Kip was born in 1843 in this important structure at 12 Meadow Road. It is recorded that in 1741, an earlier Peter Kip first possessed the land that surrounded this location. Hendrick Kip probably built the present house close to 1770, and it is likely an enlarged addition to an original, smaller structure, which is now gone. The building was also owned by Daniel Van Winkle in 1850 and J.H. Poillon from 1876 into the 20th century. Underneath the modern stucco is a handsome, five-bay center hall Dutch Colonial of coursed sandstone. It is one of the few remaining structures from the settlement along Neck or Newark Road. Kip ancestors (also spelled Kipp and de Kype) were persecuted by the French and driven into the Netherlands. They succeeded as merchants, and one became a director in the East India Company, helping to finance Hendrik Hudson's 1609 voyage to the Americas.

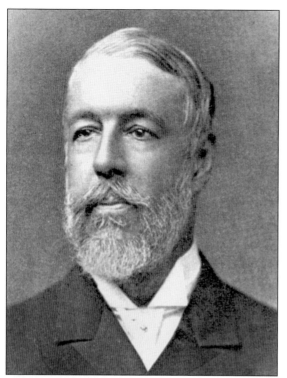

Initially, the family of David Brinkerhoff Ivison (left) fled New York City summers to the village of Boiling Spring for a cooler country retreat. They first established a residence that faced Union Avenue, close to where Hackett Street is today (below). The brownstone walls that still remain mark the basic area of the Ivison property. This "gentleman's farm" was country enough but still close to a train into the city. Ivison acceded to the presidency of the American Book Company, one of the largest textbook manufactures in the United States. As his wealth increased, he sought better accommodations in his New York residences and at his Rutherford address. At the time, the largest and most prestigious Boiling Spring property was Floyd W. Tomkins's "Hill Home," an estate at the corner of Montross and West Passaic Avenues. (Courtesy Bergen County Historical Society.)

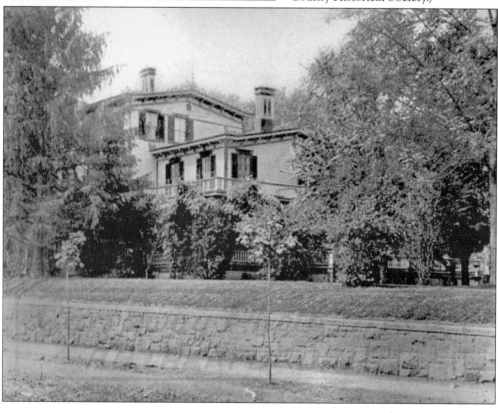

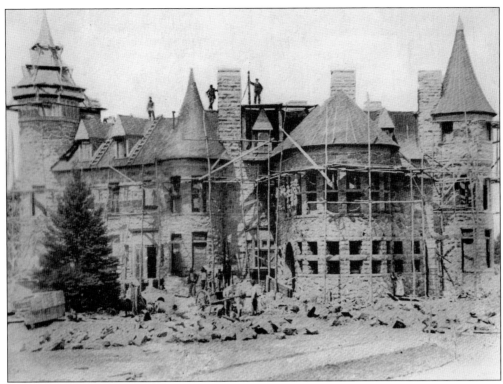

As David Ivison's fortune increased, Floyd Tomkins's decreased, and soon his "Hill Home" became available to Ivison. Not content with Tomkins's two-and-a-half-story brownstone manse, in 1887, Ivison secured architect William Henry Miller to remodel and increase the size of the original. The Chateau de Chaumont in the Loire Valley, France, became Miller's inspiration as he deployed an asymmetrical form around the original structure. It was finished with Queen Anne and Richardsonian Romanesque elements, with stones from the Belleville quarries to match the existing "Hill Home" walls. The building cost $350,000, and the Ivison family moved in during 1888. Unfortunately, David Ivison would die on April 6, 1903, having only lived in Iviswold, or "the castle," for a mere 15 years. (Below, courtesy Joyce Leenig.)

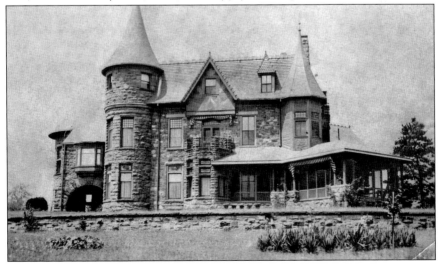

Two salesmen, Maxwell W. Becton (left) and Fairleigh S. Dickinson (right), met in a train station and realized they were both from North Carolina and shared the same birthday. In 1897, with only a handshake, they formed Becton, Dickinson and Company. First situated in New York City, the partners found a site for their manufacturing plant on Hackensack and Cornelia Streets in East Rutherford, New Jersey. After a temporary stay in the Maples Boardinghouse, they decided

to remain as Rutherford neighbors with the Bectons living at 140 Ridge Road and the Dickinsons at 185 Ridge Road. Their success in friendship and business was astounding, as Becton Dickinson became one of the largest medical suppliers in the world, and the partners and their families remained friends until the end. After their deaths, they were interred in side-by-side plots in Hillside Cemetery in Lyndhurst, New Jersey. (Courtesy BD archives.)

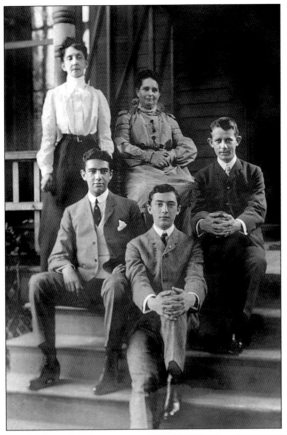

The poet Dr. William Carlos Williams (first row, right) is one of Rutherford's most prominent personalities, and rightly so. He was born September 17, 1883, and for the first part of his life lived at 131 West Passaic Avenue. Along with his brother Edgar Irving (first row, left), he attended schools in Rutherford, Switzerland, France, and at Horace Mann School in New York City. Williams also attained an advanced placement for medical study at the University of Pennsylvania. At college, he was able to define his poetic inclination through friends such as Ezra Pound and Hilda Doolittle. Williams began a Rutherford medical practice in 1910, just one year after publishing his first volume of poetry. He married Florence Hermann, a Rutherford woman, and they moved into 9 Ridge Road (below). For over 40 years, Dr. William Carlos Williams cared for his patients from his home office while delivering over 2,000 babies. (Both, courtesy Rutherford Public Library.)

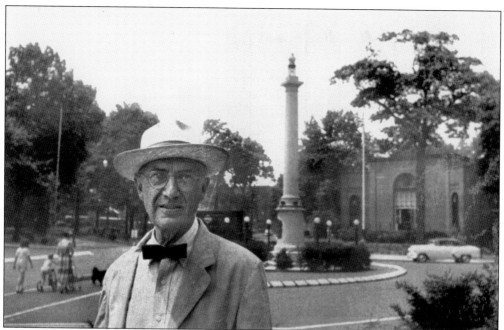

Doctor Williams found inspiration from the natural environment, classic literature, and the people and patients he cared for. He responded to common speech patterns and the concerns it expressed. He is credited with revolutionizing modern poetry through his exploration of new rhythms he introduced to the medium. Throughout his productive literary career, he was a mentor to many poets, as they would visit 9 Ridge Road to seek his advice. William Carlos Williams was awarded many commendations, including the National Book Award for Poetry (1950), a Pulitzer Prize (posthumously in 1963), and a nomination to become the 1952 national "Consultant in Poetry," or United States Poet Laureate. (Above, courtesy *Holiday* magazine; right, courtesy Yale University Beinecke Rare Book and Manuscript Library.)

Edgar Irving Williams was born on October 5, 1884, one year after his sibling William Carlos. The brothers grew up together and were teammates in almost everything. Edgar's creative side was as apparent in graphic arts as his brother's was in poetry. They remained close until they tried to date the same woman. Edgar pursued an outstanding career in architecture begun with study at the Massachusetts Institute of Technology. He was the recipient of the Prix de Rome for architecture awarded by the American Academy of Rome. When he returned to Rutherford, he married Hulda Gustafva Olsen and moved into his family home at 131 West Passaic (below).

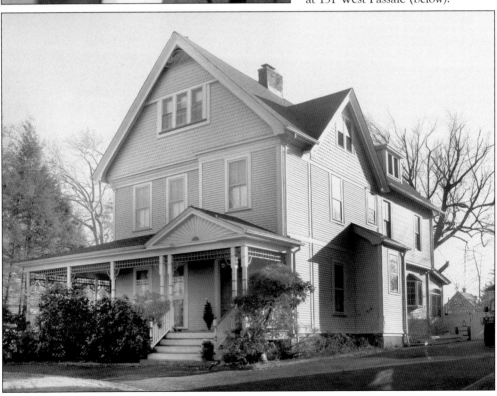

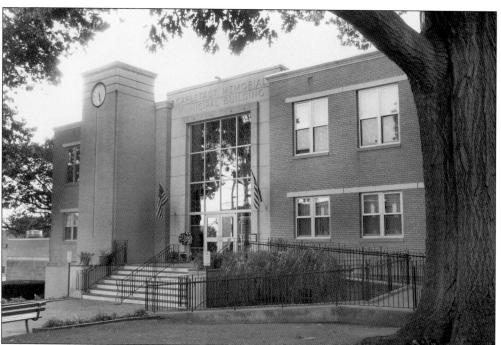

Edgar I. Williams began his professional career as an architectural designer with Welles Bosworth in New York City. He soon forged a prolonged solo practice at the prestigious Architects Building in New York City. For a time, Edgar taught at MIT, but he settled into a 25-year professorship at Columbia University School of Architecture. Like his brother, he was a mentor and became a national leader within the American Institute of Architects. Besides his many Rutherford commissions, he renovated Morven, the New Jersey governors mansion in Princeton, and the Andrew Carnegie Mansion in New York City. He designed the Donnell Library in New York City and the Municipal Building of Carlstadt, New Jersey (above). He remained at 131 West Passaic Avenue all his life, and in 1946, he was awarded the first Citizen of the Year by the Rutherford Chamber of Commerce. At right is one of the last photographs of William Carlos and Edgar Irving Williams together before the poet's death in 1963. (Courtesy Rutherford Public Library.)

Robert Leckie was born on December 18, 1920, in Philadelphia, but soon moved with his family to 146 Carmita Avenue in Rutherford. Much of his life growing up in Rutherford is portrayed in his second book, *Lord What a Family*. His long writing career began while attending St. Mary's High School as a sports reporter for the *Bergen Evening Record*. Leckie enlisted in the US Marine Corps just one month after the attack on Pearl Harbor. He served in the Pacific theater with the 1st Marine Division as a scout and machine gunner. Leckie was involved in forward action at the Battle of Guadalcanal and was wounded in the Battle of Peleliu. After being honorably discharged in 1945, he resumed his writing career in New Jersey. He married Vera Keller, a neighbor on Union Avenue, and they had three children. His first book, *Helmet for My Pillow* (1957), was an award-winning war memoir that became a basis for the 2010 HBO television series *The Pacific*. Robert Leckie authored more than 40 books on American history. (Courtesy Vera Leckie and family.)

Dr. Calvin J. Spann fought many battles. He was born in 1924 and grew up at 130 East Passaic Avenue in Rutherford. His father died when Calvin was 16, and his mother supported his family while everyone worked together to make do. He attended Mt. Ararat Church, participated in boxing and football, and dreamed of flying. While attending Rutherford High School, he submitted to a three-year college equivalency program needed to join the Army Air Corps. Wartime service called in 1943 during his last year of high school. He got his first exposure to 1940s segregation while traveling south to Tuskegee, Alabama. Calvin Spann was determined to succeed in the "Tuskegee Experiment," an intensive training course for African American pilots. He received his wings and prepared for overseas combat duty. He became a member of the 100th fighter squadron, 332nd Fighter Group, and was part of the legendary "Red Tail" fighter pilots commanded by Benjamin O. Davis Jr. Lieutenant Spann flew 26 combat missions and was honorably discharged. His outstanding service put him at the vanguard that helped end segregation in the United States. (Courtesy Calvin Spann family.)

Thomas Reeve Pickering was born on November 5, 1931, and lived on Springfield Avenue. Pickering graduated from Rutherford High School in 1949, attended Bowdoin College, and earned a master's degree from the Fletcher School of Law and Diplomacy at Tufts University. He entered the US Foreign Service and was assigned to the US embassy in Tanzania. This began an incredible career that led him to be assigned as the US ambassador to Jordan (1974–1978), Nigeria (1981–1983), El Salvador (1983–1985), Israel (1985–1988), India (1992–1993), and Russia (1993–1996.) In 1989, Pres. George H.W. Bush appointed Pickering as the US ambassador to the United Nations. Thomas Pickering retired from the Foreign Service in 2001 after being described by *Time* magazine as the "five-star general of the diplomatic corps." His ancestor Timothy Pickering served successively as postmaster general, secretary of war, and secretary of state under George Washington and John Adams. (Courtesy United Nations.)

Catherine Elizabeth "Kate" Pierson was born in Weehawken, New Jersey, but grew up on West Gouvenour Avenue in Rutherford. A self-confessed Beatles fan, Catherine played in a protest folk band called the Sun Donuts during high school. After graduating from Rutherford High School in 1966, she earned a degree from Boston University. Not sure what direction her life should take, she traveled through Europe and then sought a more rural lifestyle in Athens, Georgia. In October 1976, she was involved in a pivotal jam session with Fred Schneider, Keith Strickland, Cindy Wilson, and Cindy's brother Ricky Wilson. This musical collective became The B-52s. The name came from a Southern term for a stacked bouffant hairdo that became a signature look to complement Kate's soaring vocals. The B-52s quickly found a national audience and have sustained a 35-year history of performing an alternatively fun style of music to a huge international audience. (Courtesy butter.)

Rutherford has been fortunate to have many talented people excel in sports. James W. Garrett was a 1956 New York Giants fullback who became a longtime coach in the NFL. His son Jason became the head coach for the Dallas Cowboys in 2010. Left tackle Stan Walters was a two-time (1978–1979) Pro Bowl selection from the Philadelphia Eagles. In 1969, Bill Hands (left) was a 20-game winning pitcher for the Chicago Cubs. He debuted in 1965 with the San Francisco Giants and had an earned run average of 3.35 over 11 years in the big leagues. Recent major league baseball pitchers Pat Pacillo (Cincinnati Reds and the 1984 Summer Olympics), Bobby Jones (New York Mets), Frank Herrmann (Cleveland Indians), and Jack Egbert (New York Mets) have succeeded in baseball. Vin Mazzaro (below), drafted by the Oakland Athletics in 2005, made his major league debut in 2009 with a victory against the Chicago White Sox. (Both, courtesy Rutherford Public Library collection of high school yearbooks.)

Six

PUBLIC SERVICE AND JUST BUSINESS

Public services combined with many strong business sectors make a viable community a more desirable place in which to live and prosper. Since the beginning, Rutherford's excellent education and social networks have been supported by outstanding police, fire, health, and public works departments. As early as 1879, residents sought leadership in policing life and property, which then increased residential inflow. At about the same time, the Rutherford Fire Department first centered its operations near the railroad station to abate conflagrations started by sparks from passing trains and open fires. These efforts helped to stabilize the physical beginnings of the business district that served the area. An active community of healing professionals, medical facilities, and public health policy increased general well being and suppressed devastating epidemics. As the borough grew, sidewalks, roadways, basic utilities, sanitation, and transportation systems were progressively added through public revenue or private subscription. Every step supported a vibrant downtown, a growing business sector, and a secure and prosperous community.

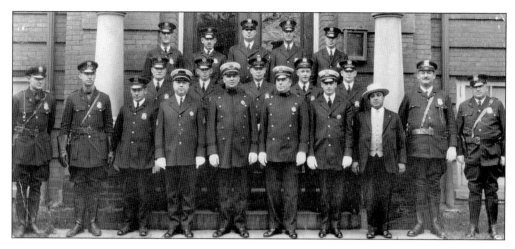

The roots of the Rutherford Police Department begin with the financial crisis of the mid-1870s and the western migration of wealth from New York City into Union Township. New Yorkers wanted assurance that their lives and investments would have an adequate level of protection in rural New Jersey. In 1879, residents sought out Civil War veteran Maj. Richard Allison to organize the Rutherford Protective and Detective Association. After the incorporation of the Borough of Rutherford, the town greatly increased the full-time police department in 1910 and 1925 (above). Constant improvement and efficiency was key to responding to a growing population, a thriving downtown (below), and multiple highway systems (Above, courtesy Mary Melfa; below, courtesy Rutherford Police Department.)

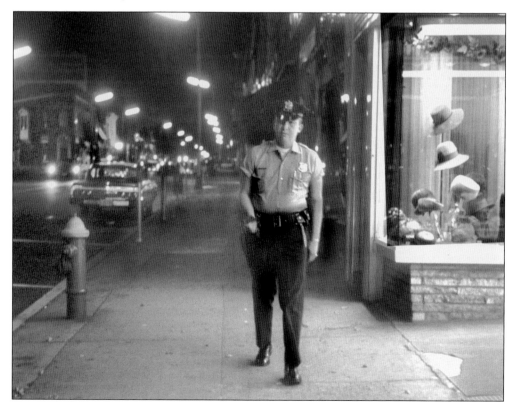

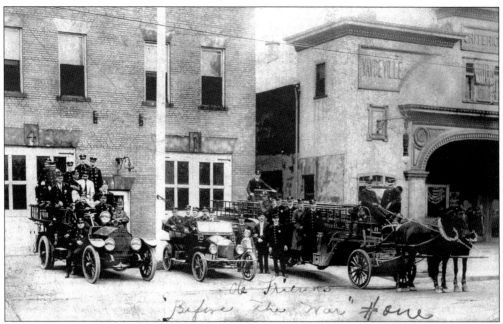

Rutherford Fire Department history begins on May 12, 1876, with the organization of the Union Truck and Bucket Company No. 1. Fire Engine Company No. 2 was placed in service on March 24, 1886. In 1913, the company moved to 167 Park Avenue (now Café Matisse). West End Engine and Hose Company No. 3 organized on June 19, 1890, and in 1925, it moved to its current home at the corner of Wells Place and Union Avenue. Rutherford Engine Company No. 4 was started in 1896, and in 1910, it moved in with Company No. 1. On November 4, 1978, Companies No. 1 and No. 4 moved into a new firehouse at 40 Ames Avenue, which became the headquarters and communication center for the Rutherford Fire Department. Fire Rescue Company No. 5 was organized in 1948 as a civil defense and rescue squad and shares the West End firehouse with West End Engine & Hose Company No. 3. (Above, courtesy Mary Melfa; below, courtesy Rutherford Fire Department.)

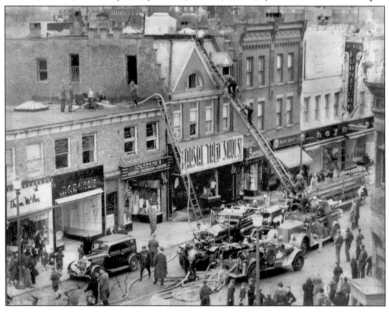

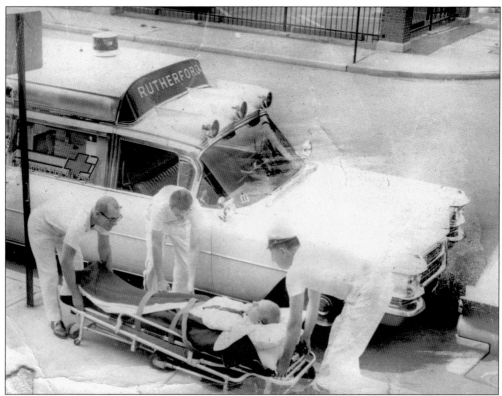

At the close of the 1940s, a group of citizens formed to organize a volunteer ambulance corps. Thomas M. Crotzer, Roland D'Ablemont, and C. Douglas Collyer found support from Rutherford's fire, police, and borough government. Eighteen members were recruited, and on August 24, 1950, the newly established ambulance corps transported its first patient to St. Mary's Hospital in Passaic. Their first ambulance was a Cadillac 8 Metro model outfitted by A.J. Miller. The corps was originally located in the old stable area in the rear of the Ames Avenue firehouse but moved into a new building in 1982. (Above, courtesy LaPierre family.)

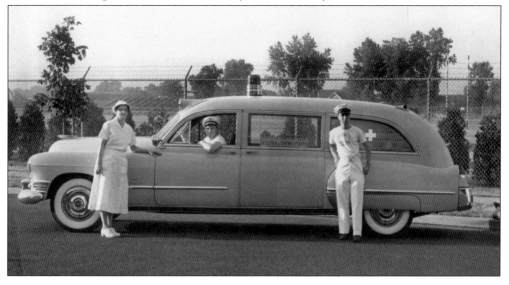

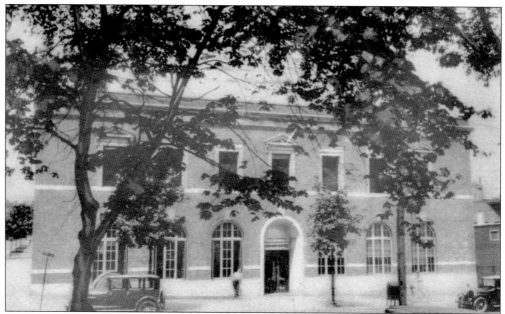

Lemparts Stationery store has the distinction of receiving Rutherford's first telephone in 1888; by 1895, the Rutherford Telephone Exchange was established at 64 Park Avenue. Over 3,000 telephones existed when the telephone exchange was finally sited at 40 Orient Way (above). Gas for public lighting was generated at the Rutherford and Boiling Spring Gas Company in East Rutherford. By 1889, the Rutherford Electric Light Company replaced gas for lighting streets. Both the gas and electric companies evolved into the Public Service Gas and Electric Company (below) with a service center located at 184 Park Avenue, now home to the police department and board of health building. (Above, courtesy Mary Melfa; below, courtesy Ed Lisy.)

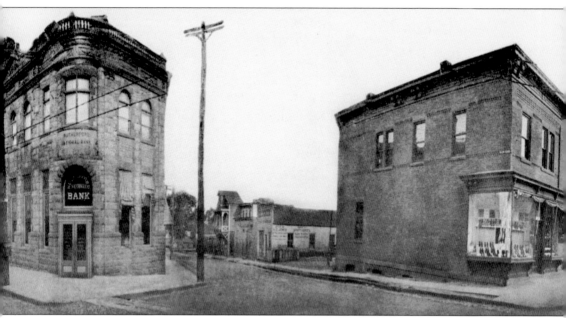

An outstanding 1920s commercial panorama of Rutherford's early downtown development shows the major intersection of Park, Spring Dell, Franklin, and Sylvan Avenues. From left to right are the Rutherford National Bank, Spring Dell Avenue, Sylvan Avenue retailers (with an open lot for the future Rivoli), the Ruckstuhl Hall, two bewildered women, Keans Market (now Kurgen

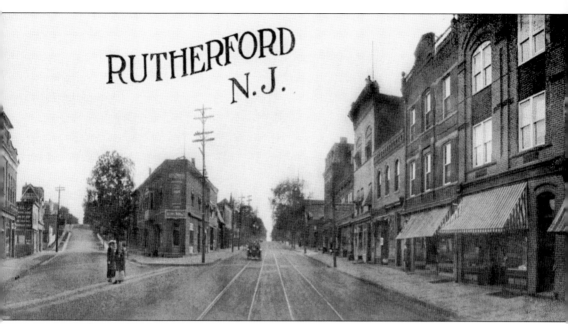

Bergen Real Estate), Union Traction Company trolley tracks, and the even side of Park Avenue retailers. To the immediate right is a section of the Borough Hall complex. The photographer was probably George Garraway. (Courtesy Mary Melfa.)

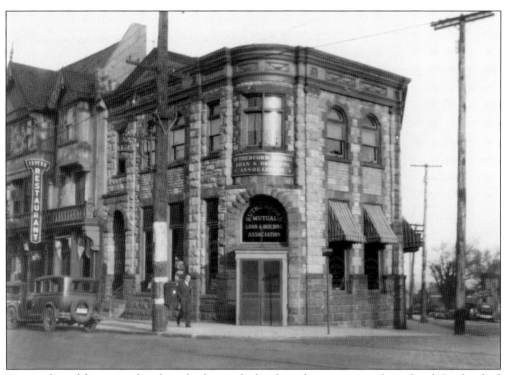

As retail wealth accumulated in the borough, banking became more formalized. Rutherford National Bank was chartered on May 3, 1895, first within the McMain Building at 9 Park Avenue. Tragedy soon struck, however, as fire devastated the building. A replacement site was chosen at 39 Park Avenue, and a new Romanesque-style building was erected. Even after enlarging the structure, it could not accommodate banking for all of the area, which now included revenue from the Becton Dickinson Company. In 1923, the bank erected an impressive Beaux Arts building to house its headquarters in Rutherford at 24 Park Avenue at Ames. Eventually, the bank opened many branches and was renamed "National Community Bank," but it was acquired by Bank of New York in 1994.

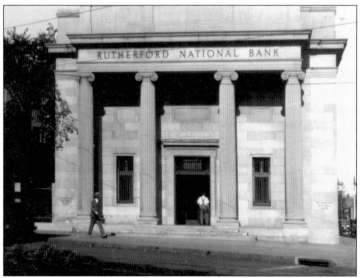

The East Rutherford Savings Loan and Building Association formed a charter in 1895 with the help of William A. McKenzie, founder of Standard Bleachery. In 1939, this bank combined with the Rutherford Mutual Building and Loan Association to become the Boiling Springs Savings Bank. It established its headquarters at 23 Park Avenue in Rutherford (right). This bank has branched out to many other communities in northern New Jersey, but it still maintains its headquarters in the Borough of Rutherford. Now, it has its own building on Orient Way (below).

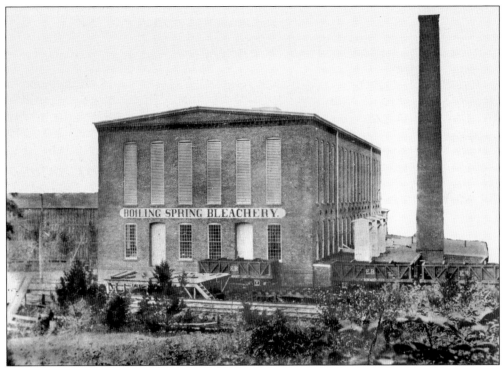

In 1886, William A. McKenzie, born in 1841 in Glasgow, Scotland, obtained the small, pre–Civil War Boiling Spring Bleachery (above) and renamed it Standard Bleachery. McKenzie also renamed the area Carlton Hill. Standard Bleachery's main output was natural fabrics suitable for dying, cutting, and sewing. The factory at Erie and Jackson Avenues in East Rutherford had a railroad siding that was parallel to the West Rutherford (Carlton Hill) train station (below). The factory was close to and used the water from a small natural area and pond called at various times "Swanwhite Park," "Lake in the Woods," and "Swan Lake." (Both, courtesy Anne McCormack.)

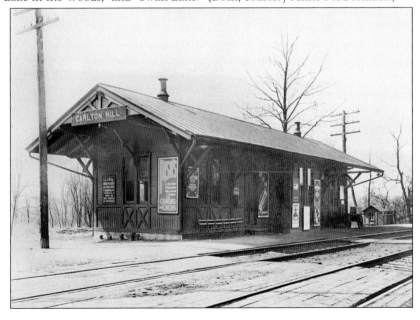

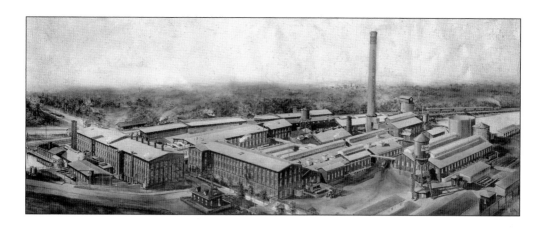

The Standard Bleachery quickly expanded to over 40 buildings (above). Up until the 1930s, this industrial complex employed upwards of 600 people. The company was so successful that in time it would provide a Sunday school, community center, playground, and 50 East Rutherford and Rutherford homes, which were leased or sold to their employees. Most of the McKenzie family would reside in Rutherford while William A. McKenzie resided in Carlton Hill and was an early advocate in the formation of the Borough of East Rutherford. He was elected the first mayor of East Rutherford in 1894. Standard Bleachery was bought out by Royce Chemical in 1967 and eventually closed in the 1980s. (Below, courtesy Christine Healy.)

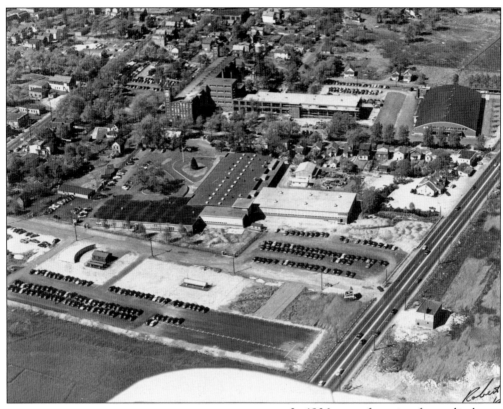

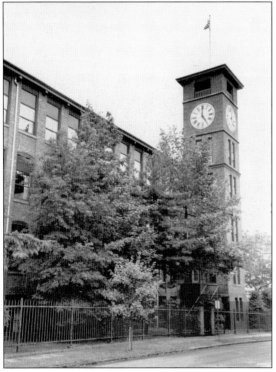

In 1906, manufacturing for medical supplier Becton Dickinson and Company (BD) was originally centered on 28 acres on Hackensack Street in East Rutherford (above). Anton Molinari, another medical supplier based in Woodridge, New Jersey, enticed the BD partners to bring their company to the South Bergen area. The Becton and Dickinson families settled into homes on Ridge Road, and all business correspondence listed various Rutherford addresses. The tall clock tower (left) was supposedly made specifically so Maxwell Becton could set his watch on his daily walk to work. Before the advent of Fairleigh Dickinson University, Becton Dickinson was Rutherford's largest employer. (Both, courtesy BD Archives.)

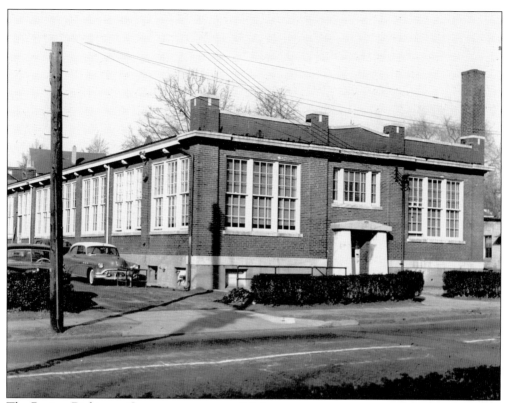

The Becton Dickinson Company grew and continued to construct additional buildings for research and development, such as 185 Hackensack Street, now the Meadowlands Hardware building (above). But explosive growth in international markets and manufacturing logistics demanded even more space elsewhere. Soon, the headquarters moved to a 140-acre parcel of land in Franklin Lakes, New Jersey, and the original facility ceased operation in 1992. Much of the land was sold to the Federal Reserve Bank and for residential developments. When the company vacated, it carefully removed the Seth Thomas four-sided clock and reinstalled it at its Franklin Lakes headquarters. (Courtesy BD Archives.)

The Rutherford climate has produced some of life's most precious pleasures in the form of flowers. The large nurseries of the Julius Roehrs Company and Bobbinks and Atkins (left) straddled Paterson Plank Road in East Rutherford close to Standard Bleachery. Both choose to use Rutherford as a business address while occupying hundreds of acres in East Rutherford. Rutherford also had a commercial greenhouse in the center of its residential core. In 1871, landscaper and florist August Nadler bought 10 plots of land on Woodward Avenue to create a greenhouse complex. Kesteloo the Florist (below) had a storefront at 78 Park Avenue, as did Nadler.

Two of the most interestingly situated businesses in the Rutherford area were Henderson Glass and the Monroe Signs Company. Gordon "Don" Henderson, born in Rutherford, was to become a third-generation stained-glass craftsman. In the 1950s, he opened his own studio in an old carriage house at 50 Erie Avenue (above). He passed away in 2010, but he is remembered for his beautiful windows created for Rutherford churches, including St. John's Lutheran, Grace Episcopal, and the Congregational Church. When the pink neon letters were fully lit, the Monroe aerial sign was a visible landmark that could guide drivers to the Rutherford trestle from miles away. Monroe Sign Company assembled sign components from the mid-1940s to 1974, but this skyline icon was dismantled in June 2007.

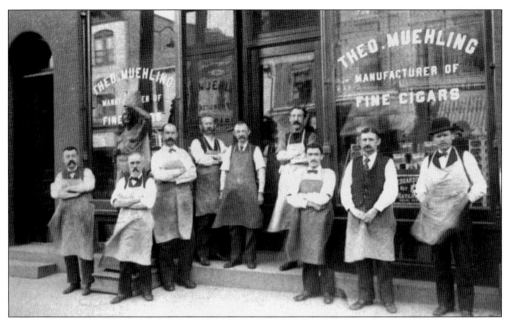

What is a town without a cigar store, or a dozen? William "Theo" Muehling started his business in Carlstadt in 1872 and became a leading manufacturer of wholesale and retail cigars in New Jersey. His prosperity brought his business to 31 Park Avenue (above) in 1893, where 15 assistants hand-rolled cigars and sold other tobacco products. At the turn of the 20th century, cigars were very much in favor, and Rutherford had upwards of a dozen retailers. Below, Stio's was a family business opened by James Stio Sr. in 1919 at the intersection of Erie and Union Avenues. By 1968, Stio's was one of only four remaining cigar stores in Rutherford. (Above, courtesy Ed Lisy.)

The 1956 advertising photograph for Triple S Blue Stamps above shows the Textile Shoppe interior, also at 31 Park Avenue. In the photograph, Albert "Pat" Jacobs was the actual proprietor, but his "customer" is really his saleslady, Anna Luke. Triple S Blue Stamps were distributed as sales rewards by participating retailers to be redeemed for prizes from the Grand Union Company. Another advertising photograph shows the 1962 interior of Madame Iola's Beauty Shop. This shop was originally a 1920 residence at 2 East Park Place, but the address was turned to 185 Park Avenue when the beauty shop was rearranged for business. (Above, courtesy Bruce Jacobs; below, courtesy Ada Iola Piro.)

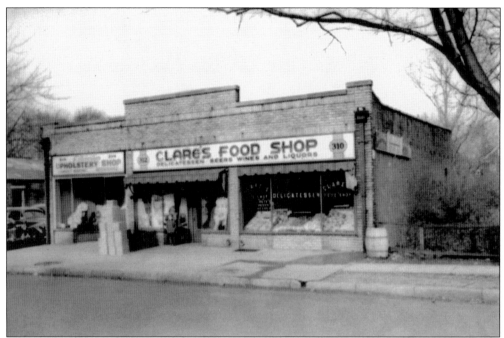

Shop Rite was the center of Rutherford's West End and its commercial district. Originally opened as Clare's Food Shop by Arthur Clare, the store had several Union Avenue addresses at 300 (1928), 319 (1934), 313 (1936), and 314 (1946) before finally opening its largest location at 310 Union. In 1956, Arthur transferred his ownership to his sons Charles, Thomas, and Paul. Charles was active in the 75th Anniversary Committee and is shown below in a 1956 publicity photograph with a sprouting beard as one of the "Brothers of The Brush." (Both, courtesy Clare Family.)

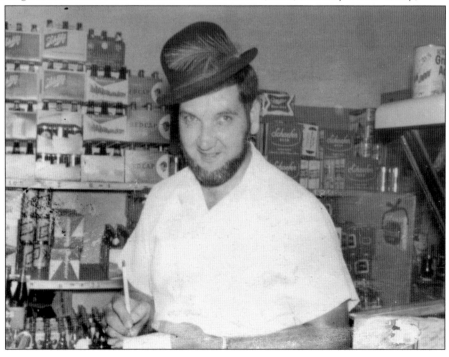

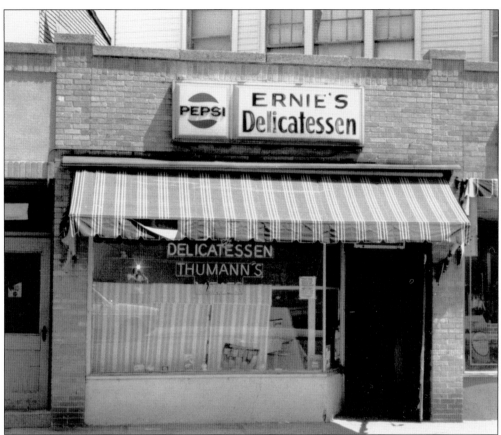

Businesses large and small have impacted Rutherford lives, and some of the most endearing have involved food. On June 1, 1961, Ernest "Ernie" Gumann opened a delicatessen at 8 Franklin Avenue. For 26 years, his salads and impromptu songs would never fail to delight thousands of Rutherford and Saint Mary students. John Jordan, Ned Bevelheimer, and Willie Henkelman originally opened the Roadrunner at 120 Park Avenue in 1969, but it was soon owned and managed by Jerry Schneider's family in 1972. It closed in December 1985. (Above, courtesy Gumann Family.)

George C. Garraway and the Garraway Photographic Studio, located at 375 Carmita Avenue, photographed much of Rutherford's history pictured in this book. Pictured above is a matchbook cover advertisement for the studio. Garraway returned from the Spanish-American War and formed a partnership with his brother Arthur. They opened a stationery and photographic supply store at 10 Park Avenue (below). George, however, wanted to produce images. He commissioned the Rutherford Cement Construction Company to build a photographic studio that opened in 1909. Garraway photographed most of the early views of Rutherford. This was not the main business, as catalogues and magazine ads brought in the greatest revenue. By 1927, the firm employed 14 men and women. George C. Garraway was a Rutherford councilman, but his service to Rutherford's visual history will never be forgotten.

BIBLIOGRAPHY

Allan, Robert. *The Evolution of The Borough of Rutherford: Municipal Planning Project 5753-2 Work Projects Administration.* Trenton, NJ: 1939.

Clayton, W. Woodford and William Nelson. *History of Bergen and Passaic Counties.* Philadelphia: Everts & Peck, 1882.

Conklin, Agnes B. and Helen J. Swenson. *Old Houses of Rutherford, New Jersey.* Rutherford Committee of the New Jersey Tercentenary, 1964.

Hands, James. *A Brief History of Rutherford, New Jersey.* Rutherford Diamond Jubilee Historical Program, 1956.

Ketchum, Dr. J.J. *Rutherford, New Jersey An Ideal Suburb.* Rutherford: *Rutherford News,* 1892.

Newark Sunday News, Newark Star Ledger, Bergen County Herald and News, Bergen County Record, New York Times. Newspapers from 1852 to 2005 in various holdings, public libraries, and internet sources.

Riggs, Margaret G., ed. *Things Old and New from Rutherford.* New York: Bowne & Co., 1898.

Historic Preservation 2006 Resurvey: A 25 Year Update of the 1981 Bergen County Historic Sites Survey. Rutherford Historic Preservation Commission, compilers, with McCabe & Associates (consultants), 2006.

Sanborn. *Fire Insurance Maps for the Borough of Rutherford.* Pelham, NY: Sanborn Company, various years.

The Rutherford American, The Rutherford Republican, South Bergen News, News Leader, South Bergenite. Rutherford newspapers from 1892 to 2005. Rutherford Public Library (microfilm).

Van Valen, James M. *History of Bergen County.* New Jersey Publishing and Engraving Co., 1900.

Walker, A.H. *Atlas of Bergen County, New Jersey.* Reading, PA: C.C. Pease, 1876.

Westervelt, Frances A.J., ed. *History of Bergen County, New Jersey, 1630–1923.* New York: Lewis Historical Publishing Co., 1923.

Discover Thousands of Local History Books
Featuring Millions of Vintage Images

Arcadia Publishing, the leading local history publisher in the United States, is committed to making history accessible and meaningful through publishing books that celebrate and preserve the heritage of America's people and places.

Find more books like this at
www.arcadiapublishing.com

Search for your hometown history, your old stomping grounds, and even your favorite sports team.

Consistent with our mission to preserve history on a local level, this book was printed in South Carolina on American-made paper and manufactured entirely in the United States. Products carrying the accredited Forest Stewardship Council (FSC) label are printed on 100 percent FSC-certified paper.

MADE IN THE USA